Using
Non-Textual
Sources

BLOOMSBURY RESEARCH SKILLS FOR HISTORY

A series of detailed research skills guides for advanced undergraduates, postgraduates and researchers in the field of history.

Published:

Using Non-Textual Sources, Catherine Armstrong

Forthcoming:

Elite Oral History, Michael Kandiah
Histories on Screen, Sam Edwards

Using
Non-Textual
Sources

A Historian's Guide

CATHERINE ARMSTRONG

Bloomsbury Academic
An imprint of Bloomsbury Publishing Plc

BLOOMSBURY
LONDON · OXFORD · NEW YORK · NEW DELHI · SYDNEY

Bloomsbury Academic

An imprint of Bloomsbury Publishing Plc

50 Bedford Square	1385 Broadway
London	New York
WC1B 3DP	NY 10018
UK	USA

www.bloomsbury.com

BLOOMSBURY and the Diana logo are trademarks of Bloomsbury Publishing Plc

First published 2016

© Catherine Armstrong, 2016

Catherine Armstrong has asserted her right under the Copyright, Designs and Patents Act, 1988, to be identified as Author of this work.

British Library Cataloguing-in-Publication Data
A catalogue record for this book is available from the British Library.

ISBN: HB: 978-1-4725-0583-5
PB: 978-1-4725-0653-5
ePDF: 978-1-4725-0539-2
ePub: 978-1-4725-0571-2

Library of Congress Cataloging-in-Publication Data
A catalog record for this book is available from the Library of Congress.

Series: Bloomsbury Research Skills for History

Typeset by Integra Software Services Pvt. Ltd.
Printed and bound in India

CONTENTS

LIST OF ILLUSTRATIONS

Introduction

Aim: This book will help the undergraduate history student improve their understanding of non-textual primary sources. It will give them the tools with which to analyse such sources and then hopefully will also give them the confidence to begin selecting such material themselves for use in their arguments.

Let us begin by asking the basic question: what are non-textual sources? I use this term to refer to any source of evidence about the past that is considered 'primary' in nature (i.e. it has something to say directly about the past rather than being mediated through the views of a historian) but that is not primarily textual. Most sources used by historians tend to be either print or manuscript textual or statistical material, such as legal documents, censuses, business archives, letters, diaries or a variety of published works such as books, magazines or newspapers. This book argues that while these items are very important types of evidence, they only partially tell the story of people's experiences in the past. In order to develop your skills as a historian, it is crucial to expand your repertoire and consider some of the visual, audio, material and environmental evidence that is available to you.

So, having shown what non-textual sources are not, let us consider what they are. Still images, such as paintings, cartoons, photographs or maps play an important role in opening up our understanding about the historical world. We also consider moving images, in the form of feature films, film and television documentaries and news recording. Radio broadcasts, oral interviews and musical recordings are important too. However, two remaining types of source must be considered and these are even less familiar to many history students: the 'thing' and the 'place'. The study of 'things' or material culture has only recently begun to be considered part of a history curriculum. An examination of 'place' in a historical context can also tell us

a great deal about the local, and global, significance of that place in times past and can also reveal individual stories of the people that lived there.

Those who have had some training in literary criticism might be surprised by the choice of the term 'non-textual' to describe these sources, and you are partly right; in many ways it is flawed. First, some of the sources we examine in this book are actually partly textual, that is, they include words, writing and limited amounts of text within them. Examples are the captions on cartoons, or tattoos and graffiti, all of which are discussed in Chapter Two. Second, and more crucially, according to recent literary criticism and postmodern theory, a source does not need to include words to be considered a text. A 'text' is anything that communicates with an observer or viewer. Under this definition a piece of art could be a text. Russian theorist Yuri Lotman outlined his views on this in the 1977 work, *The Structure of the Artistic Text*. However, I have chosen to reject this structuralist description of the nature of a text as anything that has a semiotic* purpose and instead have reverted to a more basic definition of a text as something that takes written form, whether printed or manuscript. Therefore, non-textual historical sources include everything outside this written form and can be images, still and moving, sound recordings, artefacts and places.

You may have already encountered such sources in your historical study and you may be aware of their significance as source evidence but are still unsure how to make use of them in a critical and analytical way. Then this book is for you. It will help you to learn the 'language' that these sources speak, allowing you to interpret their message and their significance. You can also begin to develop an understanding of how these sources functioned in the past, what they meant to contemporary audiences as well as their significance to historians today. It may sound odd but, in many ways, I hope when considering your own scholarly practice that this book raises more questions than answers, because approaching primary sources as a historian often does leave you with many unanswered questions. A single source reveals many complex and diverse stories about the past, not all of which you may wish to investigate or acknowledge. You may have to be selective. But this book will have done its job if it makes you aware of the fruitful and rewarding possibilities presented to you by these non-textual sources.

The increasing interest among scholars in the last twenty years in visual sources was given an official name: 'the pictorial turn'. The term was invented in 1994 by theorist W. J. T. Mitchell and refers to his belief that pictures reflect our perceptions and identity and that they also increasingly shape the world in which we live. So, as historians we need to engage with this visual world because, even if we are sceptical about Mitchell's assumption of the dual influence of the visual, we cannot deny

* Definition: the study of how meaning is made in cultural artefacts.

the ubiquity in the last century of 'the visual' in popular culture. For a different reason, the further back in history you probe, the more important the visual becomes – this time as a communication medium in semi-literate, illiterate or pre-literate worlds. Therefore, although as historians we might be unsure of the usefulness of engaging with theorists who construct ideas about the visual now, this book shows that such ideas can be applied, with caution, to the past.

However, as Peter Burke has argued, many historians fear that they are not sufficiently visually literate to engage with these sources.[1] What are the particular blocks to attaining this level of engagement? Scholars unfamiliar with visual material find that the language of the visual is challenging because of their unfamiliarity with it. The visual seems to contain many hidden messages that are designed to confuse the observer and prevent him or her accessing the source's true meaning. We are naturally suspicious and nervous. Historians are also uncertain as to whether our reading of an image is the same as that of people in the past and, if it is not, does that matter. We wonder who created an image or a thing and whether it is solely his or her 'voice' that is transmitted to us. All of these worries strike the historian before we begin to address the usual concern of the reliability of the source. This book will give you the skills to overcome your concerns or at least to address them so that you feel confident enough to approach non-textual sources and even to locate them for yourself.

In this book, you will find that the majority of the examples and source evidence come from a European or Anglo-American context. This reflects two issues with the study of visual material. First, all scholars work with what is familiar to them and the material that their field produces. I am a historian of the relationship between England and her North American colonies prior to the War of Independence. I teach modules on American history from the first contact period to the late twentieth century. Therefore, my personal expertise and interests have skewed the evidence presented here. Of course, I am not claiming that visual material from other parts of the world, such as that produced by Native American cultures, African, Indian, South East Asian, Australian, the Pacific Islands and many others is not as important. However, this does reveal a more serious theoretical point that much of the scholarly discussion around visual culture is 'Western', or Eurocentric. For example, trends in the history of art are defined by recourse to a canon of Western artists from the ancient world to the present day. This is not just a problem with visual material; explorations of literature often reveal the same thing, with the pantheon of authors studied in English literature degrees being mostly white, male and from Northern Europe or the United States. It is important for you to understand the perspective from which your primary sources are created but also the perspective of the theorists and scholars from whose work you are borrowing. Do not simply imitate their approaches without being critical of them.

Although I rejected the structuralist definition of a text, as mentioned above, I do not wish to deny the relevance of all postmodern theory to the analysis of visual material. In fact, much of what I'm trying to do in this book involves alerting history students to the significance of the ideas of semiotics. This theory states that the visual image is constructed as a system of signs that communicate with us. Why is this useful for historians? When looking at non-textual material we need to understand how present and past audiences derive meaning from that image. Is there something intrinsic in the image itself that creates the message? Or by bringing our own historical context do we create the message ourselves? Does the image mean something different to everyone?

These are challenging questions, and I hope you are not discouraged by having to confront some of them early on in the book. What I am showing is that theory can be useful to you by guiding you in your practice. Historians need to learn theory, not for its own sake but rather to help them to work out their own methodology when using and interpreting images, and recording things and places.

So, when we come to an image or an artefact, how do we feel when we approach it? I don't mean how do we respond to it emotionally but, rather, do we feel that the source will tell us something new about the past or do we feel that we can bend it to our intention and make it tell the story that we want it to. Most students lack the confidence to do the latter, but it is an interesting approach of which you must be aware. As Michael Ann Holly wonders, does art pose questions or offer answers? She discusses Hegel's ideas on art.[2] He believed that the visual represented both the *zeitgeist*, that is the spirit of the age, and also an inherent truth about the beauty of human nature but that these things were not presented in an obvious manner but rather that art had to be studied to be truly understood.

As you can see, most theorists find it difficult to dissociate the visual source from the viewer. Hegel and others argue that it is in the encounter with the viewer that a piece of art gains meaning. This is very exciting for historians because we need to consider ourselves as a viewer and to define our own mental world that we bring to the interpretation of the visual, but also we need to construct the mental worlds of previous generations of viewers in order to reconstruct that moment of contact between image and viewer.

Why do we need to spend time thinking about the relationship between the reader of an image or thing in his or her historical context? Because this is exactly what we do using textual primary sources. We derive ideas about the intended and actual audience for a piece of writing based on its content and its nature; that is, we examine clues within the text as to who the piece is aimed at and on restrictions placed on the potential audience by the physicality of the medium, such as its cost. Literary scholars are very interested in this idea of 'implied audience' and it is especially useful to us if we are studying sources for which we have little idea of their actual

audience. It is rare to encounter a testimonial from a viewer of an image or film in the past, although occasionally we can access these in letters, diaries or reviews. However, for the most part, the scholar makes assumptions about who this past audience was. These assumptions combine analysis of the content and of the materiality of the source. If the idea of making scholarly assumptions frightens you, I can reassure you that this is one of the key differences between the humanities and the sciences. While historians work with reliable evidence from the past as often as we can, there are times when it is not possible to make scientifically based deductions due to scarcity of evidence and so we have to make educated guesses based on our own historical training and our experience of similar types of evidence. Historians understand that the relationship changes constantly between creator, thing and receiver and this change is what we find exciting because it is triggered by contingencies of a particular place and time. And it is by understanding these contingencies that we can begin to access the meaning of a particular source.

Therefore we understand that we cannot determine the significance of a source unless we know who it was aimed at and who read it in the past, even if this is guess work on the part of the historian. Similarly with images, we need to understand who might have seen them and what message they derived from them. In order to do this, we need to know as much as possible about the psychological interpretation of non-textual material. One important thinker who has theorized the idea of the viewer is Jacques Lacan. Lacan's idea of 'the gaze' helps us to contextualize the 'cultural baggage' that each viewer brings with him or her when coming to an image. Lacan argues that 'the gaze' is a process rather than a quality that one has. It is the process of looking that makes us aware of our own objectivity. It is about power relationships – the gaze is not neutral. This idea has fascinated feminist thinkers, such as Laura Mulvey, who described the idea of the 'male gaze'. Postcolonial thinker, Edward Said, also adapted this theory in his idea of 'orientalism', which he defined as a perception of the East created wholly by the 'Western gaze'.

Of what importance is this to the student of history working out how to analyse visual sources? We learn the important lesson that people's interaction with non-textual sources is never neutral. It is always hegemonic and it reflects our own cultural position in relation to the creator of the artefact. Our cultural identity, of gender, race or religion for example, defines our response to the image or film. Sometimes the image or film itself triggers a response in its viewer not conditioned by the viewer's identity but by the hegemonic relations mentioned above. For example, Mulvey argues that the male gaze is so ubiquitous and powerful that women struggle to define themselves without reference to it.

Much of what I've said so far refers to the visual – to still or moving images or material culture. But this book takes its definition of non-textual sources more broadly than that and also encompasses places. In

our study of the history of the built environment, we must also be aware of some of the problems. Our own understanding of place is often very different from that of people in the past, partly because the nature of the physical landscape has changed, but also because the tools with which we interpret place have changed a great deal. Our twenty-first-century sense of place and the built environment encompasses many more places. Today we travel far more widely than most people in the past and have an understanding of a wider range of places through the media and education. We have an entirely different understanding of what is meant by 'the city' or by 'the countryside', for example, than people in the past. We must also be aware of power structures at work. Interpretations of the built environment often rely on assessing who is in control of a particular place, who owns it and whose presence is the cultural norm and whose presence subverts this. Those excluded from particular places can include the poor, the racial 'other' or women. Therefore, in our study of the world around us, we must be aware of how this world looks and why it looks that way and also of the structures within society that underpin the creation and use of that environment in the past.

But let us take a step back. We have identified many theoretical and methodological issues that confront us when looking at non-textual sources, but it is also important to stress that these pieces of evidence should be used as you would a traditional source. There are many similarities between the use of textual and non-textual sources and the next section will explore the basics. Someone has presented you with a primary source, a piece of evidence from the past. As a historian, how do you extract the information that you require in order to make practical use of it? There is a three-stage process: define, describe, analyse. The first two of these are straightforward and can be done with the source in front of you and with a minimum of extra research. What does it involve?

First, let us think about defining a source. We are interested in the nature of the piece of evidence. Understanding the 'what' question usually involves referring to 'who', 'why' and 'when' as well. As historians we are not as interested as literary or film scholars in ideas of genre, but it is important to understand what type of source it is in order to properly interpret it. Understanding an early modern will naturally involve being able to interpret the formal and formulaic preamble that was subtly changed to reflect the deceased's Protestant or Catholic leanings. But we also want to define a source in order to understand its intended and actual audience: a personal diary will reveal a different opinion than a letter or a published book by the same author. All these sources will show different sides of the author's personality and give us a greater understanding of them as a historical actor, but we must be aware of attempts to fashion his or her own identity for different audiences.

Describing a source is also crucial. We come to the source as a viewer or reader and engage with it on a personal level. What do you, as a

twenty-first-century individual, get from this source? What strikes you
as significant and important? Describing what you see might seem like
a simple task of summarizing, one that needs no particular historical
training. But you know that by approaching the source and engaging with
it, you are bringing something unique to that source. Your very act of
describing is not neutral.

Finally, we move to the analytical phase. We must understand the
circumstances of the source's production, consumption and distribution.
We consider the historical context, examining what were the big social,
political, economic and cultural developments that determined the nature,
content and physicality of this source. And finally we need to deduce
why this source matters. What does it contribute to the sum of historical
knowledge and what are some of the key problems that historians face
when using this source? It is not satisfactory to say that the source is
biased. All sources are biased and any students that make this point are
not undertaking a properly critical analysis. By that I mean that all sources
reflect a particular point of view. You need to know what it is, whose view
it is and why they hold that view. You also need to think about whether
such views were typical or unusual at the time. As you can see, undertaking
primary source analysis is a difficult job. You have to have done enough
reading of secondary source material in order to become an expert in the
place and period where that source was produced. As long as you are
aware of its flaws, no source should be discarded. The only criterion is
whether it has something relevant to contribute to your understanding of
the topic at hand.

This process involves a lot of work every time you use a primary source,
but you are already used to doing this for written sources. It is important
to learn how to do the same thing for non-textual sources too. A point I
reiterate throughout this book is to urge you to avoid the trap of using
visual material as mere illustration, as window dressing to your main point,
as an unthinking representation of the time about which you're writing.
Each source, whether painting, cartoon, photograph, map, film, television
broadcast, radio broadcast, oral interview, artefact or place should be
handled using the three-stage process outlined earlier. Grant these sources
the respect they deserve by not thoughtlessly scattering them throughout
your work but instead making them centre-stage and asking them the same
sorts of questions that you would ask of a written source.

Although there are many similarities between the non-textual and
textual primary source, sometimes the visual or the aural has something
different to tell us. It enhances our understanding of the historical past
by appealing to a range of senses. It allows us to experience a historical
moment more vividly and with an intensity that means we can share
something with people in the past. We must be aware that we bring to
our experiencing of the source a different set of assumptions and beliefs
compared to the historical audience. Our worldview is different. But

simply reading about the past does not bring it alive in the same way as experiencing it through aural or visual means. Examples of this include audio recordings that enhance our understanding of great orators. During the twentieth century, there were many examples of leaders whose performance was able to change the hearts and minds of their hearers. In order to understand the power of their performances, we must see and hear recordings of these speakers in action. Two examples are Adolf Hitler and Martin Luther King. Their success; their dependence on the power of the rhetoric; and their ability to use their own charisma to convince an audience of their cause cannot be understood by simply by reading their words on a page or by examining reports of their speeches in old newspapers. You must listen to their style of delivery and observe the way that they interact with the crowd and the crowd with them. This reveals that they were not distant, aloof figures but rather that a rapport with their audiences explains their success.

As well as bringing the experience of the past more vividly to life, accessing such sources through the aural medium can help to illuminate the audience interpretation. For example, you can experience just as millions of Americans did in their living rooms during the Great Depression, by listening to Franklin Roosevelt's Fireside Chats. You can hear Roosevelt's rhetoric, his friendly tone as he addresses you personally as though you are a friend of his and he has visited your home for an informal conversation. Of course, as a scholar it is also important to take a step back and to critically analyse the production of such radio broadcasts rather than to simply let the atmosphere of them wash over you. This book will show you how to do that. But the first step is to attempt to access the source as people in the past experienced it.

These sources must be considered not in isolation but alongside other types of historical sources. Ludmilla Jordanova has stated that the rich visual historical evidence gleaned from images and artefacts must be integrated with other types of source material.[3] As a university student you will realize that it is an artificial exercise to assess one source in isolation from others. Your aim as a historian is synthesis, the integration of information from both primary and secondary sources to help you formulate your ideas about a particular historical question. This book is not trying to convince you that non-textual sources are better or that they should be considered a category on their own but merely that they should be married with textual sources and analysed in the same rigorous manner.

Even when using a single source, textual material is significant. Writing that appears alongside the visual, for example, as a caption for a cartoon or photograph, can change the historian's understanding of the source as well as exposing the contemporary audiences' interpretations. The cartoon caption can sometimes be the 'punchline', the part of the image that makes people laugh. Without it, the cartoon would have failed in its purpose.

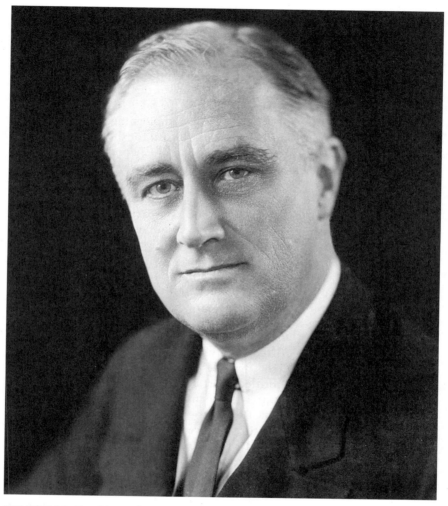

FIGURE I.1 *Franklin Delano Roosevelt, 1933, photograph by Elias Goldensky. This image is available in the public domain from the United States Library of Congress Prints and Photographs.*

Sometimes, the caption clarifies the subject of the image and makes the audience aware of an in-joke. In Chapter Two, we will explore the cartoons of Herblock made during the 1950s and the era of the McCarthyite anti-communist persecutions in the United States. Not all of his cartoons included a caption, but an example of one that did is the cartoon entitled 'You mean I'm supposed to stand on that' which was published in March 1950 in the *Washington Post*. The caption itself, recording the voice of a reluctant

Republican elephant (the symbol of the US Republican Party since the late nineteenth century) being forced onto an unsteady platform created by McCarthy's heavy handed anti-communist activity, reveals Herblock's fear that McCarthy's practices are undermining US politics. Also, the caption is not the only text on the cartoon: the label on the shaky platform for the elephant to climb on to is the first recorded use of the term 'McCarthyism'. So, as well as being an important reflection of the fears of the liberal elite in Washington at this early stage of McCarthy's campaigning, this cartoon also made history itself by introducing a new buzzword for the era (for more on Herblock, please see the case studies at the end of Chapter Two).

Another important example of the use of captions is to accompany photographs. As Derek Sayer explains, often, without a caption, viewers of photographs have little sense of where and when an image was taken. The accompanying caption can offer the contextual information that historians need in order to properly analyse an image.[4] An example of this from the earliest days of the technological development of photography is the famous 1855 image of the Crimean War photographed by Roger Fenton, one of the earliest British photographers. The caption of this image does not explicitly give the name and the place that is depicted, but the cryptic reference indicated to viewers at the time and the location at which it was taken. The photograph is captioned 'The Valley of the Shadow of Death' originally in a Biblical reference but with more immediate reference to Alfred Tennyson's poem of the previous year on 'The Charge of the Light Brigade', which also included the same phrase. The photo was subtitled 'Dirt Road in Ravine scattered with cannonballs'. In the spring of 1855, Fenton spent a few months in the Crimea and took more than 300 photographs under difficult physical circumstances. He did not capture any scenes of fighting but nonetheless managed to convey the impact of war on people and landscape, and his work, encouraged by elite patrons such as Prince Albert and the Duke of Newcastle and by art dealers, Thomas Agnew and Sons, of Manchester, represents the first systematic attempt to document a conflict through the use of photography. On his return, Fenton tried to sell his photographs, but this was not a great success; as he was independently wealthy (from a cotton and banking family), he was able to continue his photography in Britain.

Text and image, then, often appear alongside one another and the analysis of both must be incorporated into your work. Always consider the choices made by the creator of the source and the historical context of the time, no matter what type of material from the past that you study.

The significance of the internet must be considered here. It has revolutionized the way that we study non-textual sources. Image searches through search engines such as Google mean that we now have a body of material easily available to us, which a couple of decades ago would have been undreamt of. Museums and galleries make digitized images of

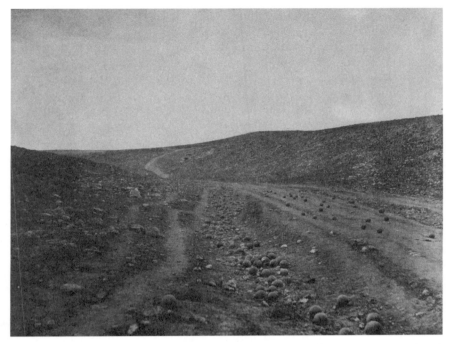

FIGURE I.2 *'The Valley of the Shadow of Death'. Dirt road in ravine scattered with cannonballs, Crimea. Cannon shot falling short of their target during the Siege of Sevastopol. Uncropped, no colour correction. Photograph by Roger Fenton, 1855. Public Domain.*

pictures and things accessible; audio and visual recordings are available via media such as YouTube. Increasingly, the internet itself is being studied by sociologists as a primary source as they study chat rooms, for example, to assess how online activity changes the norms of our society. This book only discusses the internet as a source of visual, aural and material culture. Much of the material available online is textual in a traditional sense and is only transmitted to the audience via a different medium. Our focus must remain the visual, aural and material.

Why are non-textual sources important?

Teachers of history often employ non-textual material because they believe it to be more accessible to their students. They think that by using the visual they can overcome problems faced when looking at written sources, for example, complicated, jargon-heavy language, and that the visual or aural source will be comprehensible by students with little training. I

believe that this is to misunderstand the highly complex nature of images, film and audio recordings. They have their own language too, and students must have some basic training in order to interpret what it is that these sources are saying. However, it is true that some types of sources appeal more directly to some students. This builds on the theory of learning styles. Neil Fleming identified four learning styles, dividing students into these categories based on ideas from the field of neuro-linguistic programming. Fleming's learning styles (often shortened to the acronym VARK) are: visual, aural, reading and kinaesthetic (or tactile). As a university student, you can use such models to understand your own preferred learning style. How do you best absorb information about the past? From seeing visual material? From hearing lectures about it? From reading information from a textbook about the topic yourself? Or from touching artefacts? As you can now deduce, non-textual source analysis often appeals to students in the V, A and K learning styles, using images and film if you are a visual learner, recordings as an aural learner, and material culture as a kinesthetic learner. I am not suggesting that you limit your historical research to sources based on your learning style. You must challenge yourself to develop skills in areas that will widen your knowledge base. However, by understanding your best method of learning and fitting your primary source skill development into that, you will enhance your understanding of the discipline of history.

We must also consider the issue of the emotional response to non-textual sources. We do not have time to go into the complex, psychological and biological, theory behind the emotional response to visual stimuli but suffice to say that we have a stronger emotional response to non-textual material. The processes of the brain differ when we absorb written material. We approach it and process it in a linear manner, whereas non-verbal material is absorbed more holistically. The advertising industry has been aware of this for decades and makes efficient use of the visual as a mode of persuasion. Where does that leave us as historians? Surely we should be making a rational, critical and analytical response to our primary source material, and therefore should we dismiss our emotional response completely? I disagree. It is important that we acknowledge and understand the reasons for this emotional response, whether positive, negative or ambivalent, before being able to see the source and understand it in a more logical way. This is especially true when dealing with material of a highly sensitive nature. In Chapter Two, we will discuss the best ways to respond to shocking material such as photographs of the concentration camps of the Second World War and of lynching victims in the United States.

Isolating the meaning of non-textual sources can be challenging because, as described earlier, every viewer brings different meaning. It is this range of meaning that makes non-textual sources exciting. Understanding this can also help you to better interpret written primary sources. We assume simply a piece of evidence is written that its meaning is fixed. Writing can escape interpretation more often than an image or a film or a sound. Anyone who

studies literary criticism will know that the meaning of words can be as slippery and challenging as that of visual sources. So, make sure that you carry this cynicism about the fixity of meaning into your work with textual sources too.

One way to try to fix the meaning of a source is to consider the meaning at the time of its production and look at the response of those who experienced it. If there exists a range of responses in the twenty-first century, how much harder is it to understand responses in earlier periods of history? There is so little evidence to base our assertions on. Historians therefore have to make calculated judgements based on the limited evidence available to them. In order to do this, you have to fully understand the context of the historical period in which the source was made. You need to know what was happening in history that the audience of this source might be aware of. You need to understand the cultural context of the time – how gender, race and class impacted on the lives of individuals. Particular national, regional and local differences can also help to shine a light on such an audience response.

To take the example used previously, of Roger Fenton's 'Valley of the Shadow of Death' photograph, a Victorian audience would have responded to the Biblical quotation due to their familiarity with the King James Version of the Bible and Psalm 23, from which it is taken. However, they also knew of Tennyson's poem 'The Charge of the Light Brigade' (made more famous by his status as Poet Laureate), published the previous year in the periodical *The Examiner*. The audience would then have associated Fenton's photograph with the Crimea. But who precisely was the audience for this photograph and how did they respond to it? His photography, on the trip to the Crimea, had been commissioned by art dealers, Thomas Agnew and Sons, and he exhibited his photographs for sale, on his return to England, mostly to an audience of wealthy Northern industrialists. The photographs did not make the expected impact on the art market and so perhaps provoked only a lukewarm response in the British public. Although today the idea of war photography is commonplace, this new innovation did not appeal to audiences used to more conventional landscape images of romantic Europe.

By analysing the response of audiences in the past, we understand what has changed culturally in the intervening years and what has remained the same. Historians are often simultaneously surprised by how much in the past is familiar to us, and how much is alien. Balancing these two competing ideas is the job of the historian.

Whose history are we telling?

Non-textual sources have a crucial contribution to make because they can open our eyes to a world beyond the literate elite. By focusing purely on

written sources, sometimes it can be challenging to understand the mindset of the majority of the people in the past because they were not literate and their voices appear to us only mediated through formal documents. By broadening the types of sources considered, we also broaden the range of voices from the past that we listen to. By bringing in examples of visual, aural, material and environmental sources, we become more aware of the constructed nature of history. By this I mean, we become aware of our role in telling the range of stories about the past. We see that the audience interpretation is crucial but so is a subtle understanding of voice. Whose past are we describing? Whose voice comes through to us in a particular source? Written history, either accessed through textual sources or through the ideas of other historians, is only one type of historical past. By accessing others, we allow more people to talk about their version of the past. An example is an oral history interview, in which someone who has never been considered to have a historically significant life story is consulted about his or her experiences. They, just as much as the professional interviewer, create history and we must prioritize the stories of the previously unheard.

So, part of the reason that we should include a non-textual primary source is to give agency to particular groups of people in the past. In the example of oral history recordings, agency is given to the interviewee as his or her voice is highlighted by historians. But in most of the types of primary source studied here, agency is reclaimed by examining the ways that ordinary people in the past used and understood the sources we interpret. For example, the Fireside Chats, feature films and music can all be understood by an audience of the poor and the illiterate. The masses are often the people targeted by these media. In examining the context of their creation and the content of their message, we learn about the concerns of ordinary people in the past, and by being able to reconstruct their mental world, we can thus move closer to understanding them.

We must be careful though not to be too indiscriminate in categorizing the audience. By simply labelling people 'the poor' or 'the working class' or 'the masses', we are over-generalizing and we need to be more subtle. We must develop an understanding of local, national and international identities that help to determine the response to a particular source. Gender and race are also important determinants that divide people up in terms of their understanding of a source. At some times in history, the age of an individual is also important, for example, in the 1950s and 1960s when a generation gap opened up and younger people deliberately rejected the ideologies of the previous generation. Historians also identify trends of massive theoretical changes that can contribute to this discussion, such as the Renaissance, the Enlightenment or Modernity. While these categories meant little to people in the past, it is helpful for us as scholars to have a conception of the historical period so that we can imagine the context within which source creators were working. Jordanova calls this context 'a period eye': the outlook of audience members in the past that combined their personal circumstances and

identities with the broader historical context of the time.[5] It is possible for us to look back and identify the characteristics of such period consciousness and this is one of our key tasks.

Cultural outputs, such as art or film, have also been theorized by Pierre Bourdieu who has argued that they both cause and reflect change within a culture. Bourdieu's ideas encourage us to move away from lauding one creator of a cultural artefact but to think about the conditions and structures that permitted its production more broadly. A film or a painting is created collectively by the conditions within society at that time, and therefore by examining their contents, the historian can pick up signals that elucidate the context of the culture itself. Bourdieu did not believe that a cultural product is revolutionary – that it can come out of nowhere and transcend the culture that produced it. Theorist, Antonio Gramsci, asks us to consider that such cultural products are also reflective of the power relations within society. Particular types of image or oral recording can be hegemonic, that is, reflecting the dominant forms and positions of a particular era, or they can be challenging to those structures. Both of these thinkers encourage us to look at non-textual sources because they tell us something about the culture that produced them. By focusing on these sources, we understand more about their producers and their contemporary consumers, and we also learn something of the cultural world as a whole. This is a circular process as we also need to understand the cultural world in order to interpret the meaning of a particular source, so our interrogation of the source and its provision of information must always involve an openness towards knowledge about the broader cultural context.

How we learn about using non-textual sources

This introduction has so far raised some of the reasons why you might want to incorporate non-textual sources into your work. Let us move on to consider how you do this, exploring some of the major issues when engaging practically with such material.

Historians are notoriously poor at engaging with visual, oral or material outputs of culture, partly because they feel that these are the source material belonging to other disciplines but also because they are aware of their lack of the particular knowledge required to do so. Interpreting such mediums requires a different understanding of the visual or aural languages in order to decipher them. Creating such objects requires a different type of literacy and so does decoding them. In order to develop these skills, historians borrow techniques from those disciplines that regularly use such sources as part of their repertoire. This is why Chapter One is devoted to exploring theories and methods that can be fruitfully borrowed from elsewhere. As you'll see, this is not a one-way process. These other disciplines borrow from history too. But their experience of using material such as feature films

is invaluable when developing your historical training. There is no point trying to develop your own methods for doing this when they exist already. However, it is vital to keep in mind what historians are trying to do, to tell stories about people's lives, experiences and perceptions in the past and to understand the world that led to the creation of these artefacts.

As a historian you must be aware that you also respond to sources in a particular way, just as these viewers and listeners in the past did. We have already discussed the importance of not dismissing the visceral, emotive responses to images. But you also then produce a response created by your own historical context. Your own cultural awareness and memory come into play when accessing a particular source. It is impossible for you to turn off your ability to view the source as a lay person and come to it solely as a historian. Your understanding of visual, oral and material sources is enhanced by your historical training but it originates from your understanding of culture that in turn originates from your education, your family, your social group, your peer group and is conditioned in the same way as the audience responses that you study in the past. By becoming aware of this process in yourself as a viewer, you will be able to undertake more subtle, analytical viewings of the sources concerned.

There are some particular challenges that you face when undertaking this type of source work. The first is the mistake of using the source in an uncritical way and thinking that somehow the music or art is typical of its era and can be used to epitomize a particular decade, century or intellectual development. Secondly, especially regarding films, photographs and audio recordings, is the assumption that they depict reality, that they transmit knowledge of events, people and places and ideas in an unmediated way. We find it difficult to separate the thing depicted from the thing itself. At this point historians must begin to undertake their critical source analysis as outlined above. Some types of visual media are very misleading and can be manipulated deliberately and subconsciously in all sorts of ways, which we explore in Chapters Two, Three and Four. Bring a healthy dose of suspicion with you when you analyse such sources: things are not always what they seem. Some art historians, such as Michael Ann Holly, believe that in bringing rational analytical criticism to a painting or a photograph that 'something in it dies'.[6] This assumes that we understand art best when we blank our minds and let the artwork speak to us, transmitting its pure message to us without interference. As I have illustrated in this introduction, this is not how historians see cultural artefacts. This book will provide you with the tools to interpret visual material in many different ways.

Your interpretation of the source is conditioned by your own cultural world and your upbringing, education and peer group. One way of understanding the differences between your view and that of an earlier audience's is to understand intertextuality. This word means that our understanding of all sources is affected by its relationship to sources

did not yet exist. Your understanding changes if you have seen all the subsequent sources that build on the original one, for example, if you are familiar with later parodies. Post-modern readings build on this by using later referents to examine earlier sources. An example provided by John O'Connor is that when today we view the documentary film *The Plow That Broke the Plains* made in 1936, we cannot help but think of the much more famous later production based on John Steinbeck's novel, *The Grapes of Wrath* written in 1939 and made into a movie in 1940.[7] Of course the earliest audiences for the first film could not have viewed it in the same way as we do because the latter one did not exist yet. We know that our later viewing that brings the two films together is strikingly different from earlier audiences.

How to use this book

I have written this book with an undergraduate audience in mind. I have assumed that you are studying for a history degree or a joint honours degree that includes an element of the study of history within it. Perhaps you might only be studying one module of history and are lacking confidence to approach such sources, or perhaps you have chosen a module that advertises that it will make extensive use of non-textual sources. This book is designed for first year students encountering the study of history at higher level for the first time, or for those in later years of study who have not yet had a chance to engage with visual or aural material. This book is for you, the student. Rather than being a guide book for your tutor, it will help you to develop the skills you need.

This book offers you theoretical and practical support in two ways. First, it helps you to use non-textual sources in your university coursework and second it helps you to locate such sources. So, how do you use this book? If you are about to start your degree and are thinking about the sorts of issues you will have to address when you start, reading this book from cover to cover may be a good idea. However, for most students, this is designed as a reference text that you can dip in and out of as you progress through your degree. So, for example, you may have been given a photograph to analyse or discuss in a seminar context. You can immediately turn to Chapter Two and explore the section on visual images. Similarly, with film, proceed to Chapter Three. If you have an object and are unsure how to analyse it or have been asked to consider the historic environment, then Chapter Four will be the place to start. For a more detailed theoretical understanding of the ways in which to approach this type of source, use Chapter One. This is where I describe the methods that we borrow from other disciplines. Chapter Five will be useful to you if you already have a basic understanding of using textual sources, but you need to know how to incorporate them into your work and where to find them. It will also guide you in thinking

about the skills you acquire in the longer term, how they may be useful in employment contexts. The case studies at the end of Chapters Two, Three and Four give you examples of practical ways in which non-textual sources can be used. These are not designed to be imported wholesale into your essays but rather to act as triggers for your own research, that you might then go out and find similar material appropriate to your own topic. At the end of each chapter are the key points that I hope you will take away. These can ensure that you have correctly understood the guidance offered in that chapter, but they can also act as reminders, when you work with sources of your own, to guide you in your analysis. Finally, I hope that this book will inspire in you a greater love of the study of history and that it will broaden your horizons and make you aware of different types of experience of the past, as well as making you a more thoughtful and analytical scholar.

CHAPTER ONE

Borrowing from Other Disciplines

Aim: This chapter will explain why it is useful for students of history to study other humanities disciplines. They can borrow methods and theoretical understanding from these other fields, as well as gaining insight into possible sources. However, it is always important to remember what makes historians and their work different. We bring historically minded questions to those sources and always want to know about the context of the imagination, creation, production, distribution and consumption of those sources.

As shown in the introduction, historians have only become interested in non-textual sources in the last thirty years or so. While this might sound a long time in which to develop the best methods for examining these sources, it still benefits historians to examine the approaches used by other disciplines. There are several reasons for this. We can, as the title of the chapter suggests, 'borrow' methods and theoretical backgrounds and incorporate them into our own work. We can also use their source materials and see whether these enhance our understanding of the past. But it is also an important way to examine our own practice, to work out what makes us distinctively historians. After all, if you wanted to become an art historian, or an archaeologist, you would have chosen a different programme of study at university. In the act of examining and rejecting some of the approaches of other disciplines, we are not trying to argue that history is somehow superior (although of course you may think that it is!) but rather we are creating a distinct subject identity.

In the humanities, academics are often encouraged to be 'interdisciplinary' in their research and teaching. This means that they should incorporate into their own work ideas and methods from many fields and engage in joint projects with scholars from other disciplines, bringing multiple perspectives to a single problem. However, this is often very challenging and what can happen is that scholars from different fields find it difficult to communicate with one another because they speak different 'languages', metaphorically speaking. This means that instead of being interdisciplinary, that is, borrowing and sharing from one another, projects involving scholars from many disciplines become multi-disciplinary, that is, everyone remains within their separate disciplinary boundaries with little overlap between them. What I hope to do in this chapter is to give you the tools with which to understand the approaches of other disciplines to non-textual source material. This will allow you to make your own decisions about the ideas and methods that you want to 'borrow' from them. By analysing some of the most useful and relevant sister disciplines, you will then be able to approach the specific types of sources discussed in Chapters Two to Five with more tools in your tool kit.

So, which are the most useful disciplines for us to consider? I have chosen four to discuss in this chapter, although the list is not exhaustive. Historians can also usefully borrow from sociology, anthropology and a range of other subject areas. However, the four that I have chosen – art history, film or media studies, archaeology and architectural history – contribute something specific to our understanding of non-textual sources. They are considered different disciplines to history in the modern academy, although in some cases their origins are closely linked with that of history as an academic discipline. This chapter is a plea to revisit those origins and bring the disciplines closer together once again. These disciplines can give historians the knowledge with which to explore technology (the developments that have enabled the production of different sorts of artefacts over time and that have determined the choices that artists, directors and manufacturers make in terms of colour and style. We can also borrow methods of describing and cataloguing these non-textual sources, a subject-specific typology, created by art historians, film studies scholars and archaeologists, meaning that we do not have to invent a whole new language ourselves. Finally, we can borrow an understanding of how and why interpretations of taste, beauty and style changed over time.

In art history, the main focus is on works of art such as paintings and sculptures and the conditions in which they were created, viewed and perhaps purchased, throughout their life. The origins of art history as a separate discipline are to be found in the nineteenth century. The so-called founder of modern art history was Jacob Burckhardt, a Swiss scholar who taught in both Switzerland and Germany and who is also credited with being one of the first cultural historians. Art historians are

concerned not only with the provenance of individual pieces but also with trends in artistic expression and techniques, such as the Renaissance or the emergence of the Impressionists. The named artist is revered as the sole creator of a work, and his or her name will add tremendous value, both in monetary terms and by bestowing status on the work. As you can see, historians have much to learn from an art historical approach. However, we will use paintings and other artistic materials very differently as shown below.

Film or media studies is a discipline that has had a chequered reputation in British academic life. Some commentators see it as a 'soft' subject with little to contribute to the sum of our knowledge about the human condition, but I disagree. When employed precisely, the techniques of film and media studies can be of great use to the historian. The discipline emerged as 'communication studies' in the early twentieth century and itself borrowed methods from psychology, sociology and anthropology. Like art historians, film and media studies scholars value the film, TV or radio programme in and of itself. They are interested in two aspects of these media artefacts: the way they were produced and what their content means. They explore technological developments but also the *oeuvre* of a particular director or actor. Media studies scholars also want to know about the messages transmitted to the audience through visual and oral means, by manipulating various aspects of the production including the visual cues in the *mise en scène** for example.

Non-textual sources also include the objects of everyday life – 'things' that people in the past surrounded themselves with such as their furniture and domestic goods. The history of this material culture and its remnants has been studied by archaeologists since the era of Ancient Greece, although in modern times it rose in prominence during the early modern period through antiquarians who collected artefacts from a particular locale. In archaeological investigation, much of the evidence is fragmentary. Scholars in this discipline may rarely see a pot in its entirety, as used by people in the past, but rather they find only a tiny piece of it. Using computer-generated reconstruction, they can now recreate the artefact that they have found. Archaeologists are also very interested in the landscape, both built and natural, and use similar computer techniques to reconstruct places and sites now buried or lost. Another discipline, human geography, has much to teach historians about humans' interactions with their natural world. If we are to attempt to use, for example, a city, a harbour, a market, a river or a cathedral as a source for historical study, geographers can help us to theorize about its origins, its significance and, in some cases, its decline. Maps are also a

* Definition: 'the visual theme', that is, the visual elements of a particular frame of a film or production on stage, such as position of actors, lighting, set, costume.

crucial resource for both historians and geographers, although as we shall see, historians ask very different questions of these maps.

Before we go on to explore the theories and methods of these disciplines in more depth, I want to spend a moment thinking about what it is that historians do differently. Surely there is a danger that as we borrow ideas and methods from other fields, we then lose our distinct subject identity. You may ask 'would this matter?' I think it would. Historians do things differently and here's how. Historians' main focus is human activity in the past. They are interested in what changes over time and what stays the same. They want to find out from non-textual sources how people understood their lives in the past and what was important to them as well as what they did. So, non-textual sources can be a way of accessing people's interior lives as well as their external behaviour.

Historians are less interested in aesthetics than scholars of other disciplines. By this I mean that they want to understand the significance of an artefact regardless of the aesthetic value placed on it. To give a crude example, the painting of a scene from the book of Genesis on the ceiling of the Sistine chapel in Rome by Michelangelo is as interesting to a historian *but not more so* than a painting on the wall of a rural English church done in a naive, folksy, vernacular style. It is not artistic quality but the conditions of its production and its meaning to viewers at the time and since which interest historians. Similarly, historians are less concerned by the film as a work of art, as part of a director's career trajectory. Although the narrative arc is interesting, they are more interested in what the film can tell us about stereotyping, about national, local and gender identity. Also, what does this particular film represent in the history of Hollywood? Was it produced under conditions of censorship such as the 1934 Hays Code, for example? Historians are also interested in why these sources were created. Was it in response to a public demand, to private patronage or to state demand? While it can be very difficult to access audience response in the past unless we can find a letter, diary or oral account that describes an individual's attitude to a piece of art or film, as far as popular media like film is concerned, it is possible to derive an understanding about the attitudes of the time, because the film was intended to make money by being popular and so supports people's assumptions about themselves.

Historians are also keen to use non-textual sources alongside more traditional textual sources. While archaeologists and geographers tend to focus on material culture or the landscape, historians wish to use these in conjunction with the archival record. But what is the relationship between the two types of evidence. Archaeologists tend to view the material evidence discovered on site as scientifically valid, as long as it is recorded carefully. They then go to the archival record to 'confirm' what they have already discovered. They are also interested in the particular spot in the ground in which that item was found. The attitude of historians is somewhat

FIGURE 1.1 *St John the Baptist Church, Clayton, West Sussex, chancel wall painting, photographed in 2010. Public Domain.*

different. They often prioritize the archival evidence although I argue that they ought to give equal weighting to both. So how in practical terms would you give this equal weighting? Say you had as a piece of primary source evidence a part of a pot. Historians would be less interested in where it was found and what other evidence surrounded it. They would want to know who owned it, who made it, who bought it, who threw it away, and why. They would want to know the cultural, economic and social developments that informed the creation, use and destruction of the item. Some of this can be deduced by looking at the shard of pot, some of it by understanding where it was found, but much of this information requires the archival record in supplement. For example, historians would turn to land records to show who owned the house where it was found or had access to the midden heap and to business archives to show the history of the manufacture of the pot. And once dated, we would want to provide an understanding of the historical context of the period, so that we can interpret, for example, the significance of a person of a particular status or gender using such an item.

So this book pleads not for non-textual sources to be used on their own or to be prioritized over traditional textual and archival material but rather

for our understanding of the past to be enhanced by the two being used in combination. It also emphasizes the vital interests of the historian: that of historicizing.* The piece of art or piece of pot itself is not of value, but its life from creation through to consumption and perhaps destruction is.

To complicate matters further, the other disciplines discussed in this chapter have also begun to borrow from history. Our own subject area also has techniques and methods to offer. From the late twentieth century onwards, scholars in the fields of literary criticism and film and media studies have incorporated into their own disciplines an aspect known as 'historicism'. This basically means that they realized that without understanding the context of the creation, distribution and consumption of the artefacts that they study, they were only telling half the story. As art historian David Freedburg argued, as early as 1989, his response to medieval images and his desire to historicize them had made him interdisciplinary.[1] Scholars from these fields interested in making full use of historicism are actually following similar paths to historians, further contributing to the cross-pollination of ideas between disciplines.

Art history

This section will explore three key themes. First it will show how art historians interpret works of art. Then it will look at what makes something a work of art (as opposed to a mere artefact or a functional item). Finally it will think about the way art historians interpret the creation and production of art, with the named artist as paramount.

Fundamentally, in order to analyse a painting or sculpture, art historians argue, we have to look at it. Information gleaned from elsewhere about the creation, value and provenance is also important, but we understand the real meaning of a work of art by looking at it ourselves. This viewing is undertaken with what is sometimes known as the 'subjective gaze'. What this means is that every time a new person comes to look at a work of art, they bring different preconceptions, different 'baggage' with them. So does a piece of art mean something different to every individual, and if so, what is the point of studying it if its meaning is never fixed? Some historians agree with this rather cynical view, but many believe that it is possible to historicize the subjective gaze. This means that we try to interpret why audiences in different periods of history had the reaction that they did.

This begs the question how can we generalize from the specific piece of art and our responses to it (and those of people in times past) and expand

* Definition: Historians always want to put things in their historical context, by understanding what else was going on in the world at the same time and what intellectual and cultural movements affected those alive in that period.

this to discuss particular intellectual and cultural movements. The case study approach to history involves taking one specific example and trying to extrapolate meaning from that by comparing it to others and asking in what ways is it typical or atypical. Although this has flaws, it is incredibly useful, especially when studying a period and region for which there is a lack of evidence. So can we use art works in the same way, claiming, for example, that Van Gogh's 'The Night Café' epitomizes the intellectual output of *fin de siècle* Europe? It is important for historians to challenge the lazy assumption that links a source to its time and place of creation without any analytical work that contextualizes it. This involves critiquing three important notions in art history: tradition, worldview and *zeitgeist*.[2]

'Tradition' in art refers to the methods and stylistic influence of art from a particular period or region. So for example, the 'classical tradition' refers not only to art works produced during the heydays of Ancient Greece and Rome but to the influence of those styles and techniques throughout history. This term is often connected to an old fashioned way of viewing the history of the world driven by key civilizations. However, the term 'tradition' can become more amorphous still, referring, for example, to the Christian tradition in art. Historians find these terms disconcerting for several reasons. It seems to homogenize and generalize too much. Works of art cannot share meaning simply because they share aesthetic origins. The intention of the artist is much more complex: perhaps he adopted these methods to challenge accepted notions by satirizing them or perhaps he was pressurized into doing so, to please a patron or to avoid punishment. Why is the artist using these stylistic methods? How does the commercial commodity world fit into this? If the artist is trying to sell the art work, then the issue of perceived audience response comes in here.

'Worldview' is a way of understanding the intentions of an artist and the interpretation by an individual or collective audience that helps us to think about the meaning of a piece of art. Just as the idea of 'tradition' is defined by broad categories relating to a European way of viewing the world, the idea of 'worldview' is similarly broad. It assumes that an individual's intention in creating art or perspective is defined by 'worldview', the lens through which we view the world. In the twenty-first century, many people who talk about 'worldview' do so in a religious way, discussing 'the Christian worldview' for example, but there can also exist all sorts of other 'worldviews' such as humanist or atheist. 'Worldview' can be a way of accessing the subjectivity debate: the idea that everyone's worldview is unique and identical to no one else's. Or a particular society, political group or period in time can produce a worldview that is shared between many people.

Probing that idea further, *zeitgeist* is a German term meaning 'spirit of the age' and if we accept that there is such a thing as the spirit of the age that distinguishes one era from another, then it is a small step from there to assume that cultural production undertaken during that period must

contribute something very specific to the *zeitgeist* as well as reflecting it. For historians this is problematic because we want to ask 'what is "the age"?' It is something that is constructed afterwards, in retrospect, as we make assumptions about cultural change and continuity and try to parcel the past up into easily comprehensible packages. Thus, we understand in retrospect what the Sixties means as an era; it has its own identity and cultural output. Art of the Sixties such as Andy Warhol's works are seen as reflecting and contributing to the *zeitgeist*. However, let's be more precise. In what ways were the so-called Sixties different to the late 1950s or the early 1970s? Does a particular period of time involve a shared experience by everyone, regardless of geographical location, class, gender, race and nationality?

Value

Art historians make judgements about what counts as a work of art. In this chapter, I have referred to 'the artist' using the pronouns 'he or she' but the discipline has tended to prioritize the work of male artists while neglecting the output of the many women who have produced artwork. For example, in medieval Europe, elite women and nuns such as Hildegard of Bingen produced paintings, embroidery and manuscript illumination worthy of note, but this has been traditionally ignored. Historically, women have found marketing and trading their art challenging and have been unable to attract patronage. Secular women have had their achievements belittled and ignored by the establishment, which has erroneously attributed their output to men. The art historical world is also restrictive in its geographical scope. Much of its focus is based on a Western, Eurocentric intellectual tradition deriving from Ancient Greece. Periodization is defined by changes in European history and intellectual traditions such as the Renaissance that would mean little in, say, a Chinese or Native American context. Not only are vast areas of the world excluded from the story of art history by the creation of a canon, but many creators of painting and sculpture from within Europe are neglected because their work was not part of the wealthy system of patronage and publicity that brought artists to fame. Many practitioners are labelled 'craftsmen' rather than artists and their output is dismissed with the labels 'naive'* or 'folk art'.

This allows us to engage with a debate in cultural history about the significance of high versus low culture. Certain cultural products are

* In art criticism terms, 'naive' has a slightly different but related meaning. It means that the piece is recognized as historically interesting or of local importance but is undertaken without the skill and polish of an artist or access to the latest technologies.

considered 'high' culture and this not only relates to their aesthetic value but also to the class of their consumers. So, in twenty-first-century Britain we might compare the cultural significance of opera to that of a football match. However, in the last decade, distinctions have been dismantled by arbiters of culture such as state funders who try to manufacture a more diverse audience for so-called 'high culture'. Art galleries and theatres who reach out to the traditionally alienated audiences are given more money. In historical terms, the high versus low distinction is problematic too. Cultural productions can change their relative value over time. For example, today theatre is often considered an elite pursuit, whereas in Shakespeare's England it was considered 'low culture'. Therefore when we look at works of art, it is important that we understand the nuances of the typological system that labels something proper art or folk art. But we must try to transcend those labels when making our own assessment of the meaning of a piece of art.

Historically, value was placed on art works for two reasons. Firstly the reputation of the patron, whose prestige gave an artist and his or her work a particular cachet among the populace that will be discussed further below. Secondly, a piece of work achieved value if the cost and quality of the materials used to create it was high. Gold leaf is an obvious example of this type of material, but other artists' materials were incredibly expensive, the most expensive being the best quality ultramarine blue paint made from ground lapis lazuli, reserved for colouring the clothes of the central figure of the picture. Hence, colour choices during the Renaissance were not only aesthetic or iconographic decisions but also economic ones.

The creators

Choices made by the artist are of great interest to the historian. Because art historians start by thinking about the interpretation of a work first, they start at what seems to be the end of the process. Historians often argue that to understand viewer responses, including our own, we need to put the work of art in its production context and think who conceived it, who produced it and how was it distributed and sold. What was the intention of those engaged in this process? And in trying to answer these questions, we come to the thorny issue of the role of the artist and others such as patrons. Attributing a work of art to a single named artist is problematic. We know that from the ancient world through the medieval period and Renaissance and on into today, works of art are not always the product of a single hand, the brainchild of one creative genius, but rather the work of a studio, a number of different contributors. Much of art historical scholars' work has been to observe the subtle differences between, for

example, the painting of the hands on a portrait, showing that 'the master' probably did not undertake this work.

Interestingly, this understanding of the relationship between a master artist and his apprentices who are allowed to complete small aspects and thus learn the artistic techniques mirrors that of the craft and guild system of medieval Europe. So, perhaps high art is not so far removed from other crafts after all. As Ludmilla Jordanova has said, the distinction between 'art' and 'craft' changes over time. The role of labourers and designers must be considered. Since the medieval period when guilds were protective of their professional knowledge, purveyors of that knowledge have been admired and privileged. But those who manufacture an artefact are often ignored by art historians, even though it is they who have the familiarity with the materials and technology, and instead designers (the creative genius!) is given a much higher status.[3] He (or she) may not have been hands-on in the production process but will have been aware of market, audience and message.

So, all of this complicates the most basic question that historians like to ask of their sources: whose message is the artefact conveying. Answering the question 'who' is the prerequisite for interpreting the significance of any primary source. However, by understanding the context of production, we can often overcome such concerns. After all, we often use textual sources that are anonymous or written on behalf of an institution or large number of people. When assessing an art work another contributor must be considered, one who will not have had any practical role in the creation and production of the work: the patron. Patronage had its roots in ancient Rome and in the early Christian church. Throughout the medieval and early modern periods, artistic endeavour was accomplished in almost all cases with the aid of a wealthy patron. Indeed, much of the early printed textual material and scientific experimentation also relied on funding and support from a patron, as did society as a whole. Your sponsor from the higher echelons of society would enable you to get work among their friends, from the court, state or church. An artist did not depend on selling his or her work in order to earn a living and so be able to continue their art but received patronage from a wealthy person or family to whom they were attached. This relationship was often fraught with difficulty, especially in the violent years of medieval Italy when rival factions regularly fought each other for territory and power. Not only were there practical difficulties such as this but also an artist's freedom to represent what they wanted to on canvas or in stone was severely limited by the patronage relationship. Patrons often micromanaged artistic projects and inputted their own ideas as to technique, colour scheme and style. They often insisted that they appear in paintings in incongruous settings, for example, in donor or votive portraits in which the patron appeared alongside biblical figures such as at the feet of the Madonna and Child.

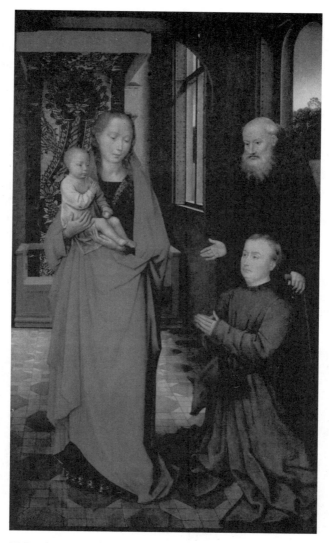

FIGURE 1.2 *'The Virgin and Child, St Anthony and a Donor', Hans Memling, late 15th century. Public Domain.*

Iconography

Art history students receive training in the subtle language of art, also known as iconography, and it is important for historians to adapt to our own purposes. The symbolism within art can seem bewildering to the uninitiated. It requires familiarity with religious iconography deriving from the Bible or from early Christian history, for example, the depiction of St

Catherine of Alexandria with a wheel or St Jerome with a lion. Many other images were used iconographically, for example, the depiction of flowers. A lily represents the purity of the Virgin Mary and later the purity of all women. Many genres of media have adopted their own iconography, such as films and cartoons. We will discuss this further in chapters two and three. This use of a visual language may seem baffling a first, but it is important to regard it as shorthand, a brief and easy way of referring to a complicated idea. The artist assumes that his audience will understand his reference. And we go back once again to the question of getting into the interior mind of an individual viewer. Historians are always confronted by the challenge of understanding what people in the past thought of this artwork.

Realism is another important aspect of art history. When looking at art that depicts people or places in the past, it is tempting to ask whether this depicts the past as it really was. Is it realistic? However, this is the wrong question to ask. As we've seen above, for many artists, depicting life as it really was is not a concern. They want to convey a message through their use of icons. Another key example of this is in composition. Many family portraits during the early modern period depict a scene that is impossible: it simply cannot have taken place as painted. An example of this is David Des Granges' early seventeenth-century painting of the Saltonstall family.

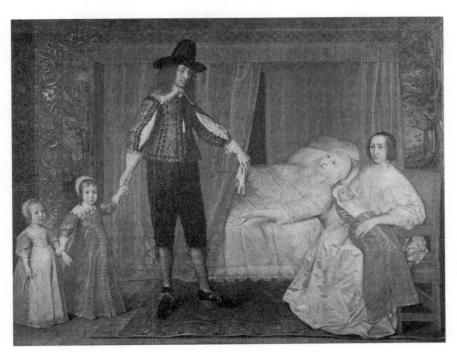

FIGURE 1.3 *'The Saltonstall Family', David Des Granges, 1636–1637. Photo:* © *Tate, London 2015.*

The painting shows Richard Saltonstall's deceased first wife alive but ailing in bed, while his second wife and new child sit quietly by. The Tudors were fond of employing similar tactics. During Henry VIII's lifetime, his third wife Jane Seymour, although she died very soon after the birth of her son, the future Edward VI, is depicted as alive and well in many portraits showing the boy growing up. When Elizabeth I came to the throne, she patronized artists depicting allegories of the Tudor succession showing her late brother, sister and father alive, gathered for a portrait with her. This illustrates the importance of moving away from what the work of art depicts and learning as much as possible about the context of its production: date, artist, patron, as well as the political, social and economic background.

By uniting the approaches of history and art history, historians can begin to use these sources to answer the questions that interest them. As Sarah Barber said, historians should not shy away from making aesthetic responses to the content of works of art as well as attempting to historicize them.[4]

Film and media studies

This section will be divided into two. First we will examine the reasons why historians might want to use film and the film industry as a source of information about the past and we will think about ways of doing this and important problems that have to be overcome. Second, we will look at what the discipline of film studies tells us about the theoretical and practical uses of feature films (movies) as primary documents.

The historian and film

There are two basic ways that historians engage with film, firstly as a way of disseminating the findings of their own research and secondly as a source of information and evidence in their own research. We do not have time here to explore the first way. The relationship between historians and film-makers is a tense one because the values and purposes of each are very different. Historians wish to convey their research findings, whereas film-makers primarily wish to entertain, to attract an audience and funding and to make a profit. These two aims do not always sit well together. The relationship can work, for example, in the case of the historian of early modern France, Natalie Zemon Davis and her involvement as a historical consultant in the making of the 1983 film *The Return of Martin Guerre*. Zemon Davis simultaneously published a book revealing her findings, and both the book and the film were very well received by scholarly critics and film reviewers.

Our focus here must be the ways that historians use film not as an outlet for their research but as evidence for their arguments. What use might films be to a historian? We can look at movies and ask how they represent history

by looking at films that depict the historical past. Or we can look at films more analytically and ask what they tell us about the time in which they were made by examining the social and cultural history of the time and relating the film to its context.

The film industry itself also has a history worth studying, because it reflects many aspects of social, economic and cultural development from the late nineteenth century onwards. Films can also help to shape society and culture too. We must understand two critical aspects of the study of film: the contexts of their production and reception. The international technological innovations that took place permitting the rise of the motion picture industry and the places most involved with this change, such as Los Angeles, are crucial aspects to study. Historians of the film industry will look at business structures, changing models of manufacture of film, and the developing cultural significance of the movie star, and the surrounding machine of publicity and studio manipulation. The response of the state and of audiences to movies is also vital. The state aims to control a powerful cultural tool such as the film industry with taxation and with legislation to censor or to ban. In the second half of the twentieth century, laws were passed to attempt to ensure that children of certain ages had no access to particular types of film. During times of war and national emergency, the industry is used as a propaganda arm, to disseminate messages of the government. However, the relationship between the industry and the government has not always been friendly, as displayed in the United States during the McCarthy era, when Hollywood was particularly targeted during the 'red scare'. McCarthy and the FBI aimed to expose communists within the movie industry because they feared it was a left-leaning hotbed of 'red' activity but also because they recognized its power to influence the US population as a whole. Independent film industries outside Hollywood are sometimes ignored in the story of the history of film but it is important to reclaim their stories. This is a global medium. While culturally the United States has used the output of Hollywood to carry its 'soft' power around the world, other nations, for example, China and India, have emulated Hollywood and produced home-grown movies of their own.

The film industry along with radio, magazines and later television and, at the end of the twentieth century, the internet have all been crucial to the development of what we think as mass culture today. Its impact is controversial. On the one hand, these cultural outputs have produced a democratization of culture, allowing people access to ideas regardless of their wealth and status. Artists have been able to spread their work to a much diverse and geographically disparate audience. They have responded to the increase in leisure time of the majority of people who are no longer solely concerned with food production. They have enhanced a culture of consumption, creating desire through advertising and through the use of star vehicles and promotions. But they have also created a homogenization of culture, where local variations have been eroded.

But far from having a solely cynical view on the impact of popular mass culture, it is also important for historians to recognize its complex interaction with people in the past. The film industry not only causes cultural change, it also reflects it. When movie makers make particular decisions on the messages that they produce, they are not doing so in a vacuum. They are trying to attract as large an audience as possible and to do that they can take two different approaches. They can either offer audiences what they want to hear, reassuring messages that reinforce their view of the world, in which case a movie will reflect the cultural mores of the time. Or film-makers can deliberately try to challenge the values and morals of the audience that it is targeting. Far from comforting them, in this case a movie would cause discomfort and psychological shock but in many cases would also result in a highly successful venture (in terms of audience numbers and therefore revenue) because of its controversial nature. In this case, we cannot simply assume that a film reflects the attitudes of its audience, but we must investigate whether it has helped to contribute to a change in attitude.

By accessing film reviews it is possible to get a sense of the way that a movie was received. But audience response is difficult to quantify, unless you have detailed evidence about contemporary audience response. It is important to remember that movies are accessible to almost every member of society. Literacy is not required as with books, magazines and newspapers. Attending the cinema (or increasingly accessing films on devices at home) is not prohibitively expensive when compared to the typical weekly wage. Therefore the issues of class, race and gender are crucial when considering the significance of a particular movie. To assume that particular audience members responded in certain ways because of their class, gender or race profile is too presumptive. Individual psychology and personal circumstances can play a huge part in audience response.

We are perhaps close here to saying that it is difficult to pin down the response of an audience. Therefore, is it possible to pin down one meaning of the film based on the audience response? Postmodern theory has given historians a real challenge when trying to interpret movies. However, by analysing films as documents themselves, using tools offered by film studies, we can perhaps come close to defining a way of understanding the meaning of films as primary sources.

Interpreting films

Film studies can help us to interpret three important aspects of an individual film. Firstly is the importance of understanding the visual language. As with paintings and art, there is a visual language that scholars in that field are familiar with. History students are, of course, familiar with movies in their leisure time. We all are exposed to movies every day as cultural artefacts. This can make us feel familiar with the medium. But when it comes to

probing more deeply and analysing the intentions of the creators of the movie, we can fall short. The discipline of film studies gives us the tools to do that. John O'Connor describes some of the most important ways that history students need to think about films.

Each film is made up of multiple shots. Film studies scholars can spend hours analysing a single shot. The way that a director has constructed a shot conveys a particular mood and meaning. The construction of a shot is known as the *mise en scène*. Directors and editors spend a great deal of time preparing this. They also think about the other visual elements such as length of shot, lighting and use of colour. Sound is also an important part of the production: the choice of a particular musical soundtrack is not accidental. Equally, the combination of music with certain visual cues can heighten tension, for example. The dialogue is a vital part of the film for conveying meaning but it is only one small part. Visual and aural language more broadly must be taken holistically. Editing techniques are also crucial in developing the meaning of a film: removing certain frames can completely change the nature of the narrative.

A second aspect that the discipline of film studies discusses, which is closely related to the first, is the development and use of particular types of technology. We are used to consuming films without thinking about the practicalities of how they were made. We need to understand the science of human vision, of photography and then finally of the moving picture camera.

Finally, film studies scholars have a structure in place for the theoretical interpretation of movies. They interpret the aesthetics of a film and derive significance and meaning from that. Films are not attempting to be direct representations of a particular reality. They use visual stimulation to manipulate the viewer's emotions and attitudes. Films have 'codes' that they use, shorthand metaphors to epitomize a particular era or message, because they have developed a shared visual language. An example of this is the use of shots of an empty Monument Valley in numerous Westerns to depict the struggle faced by Americans against both the landscape and natives. We need to think about the narrative arc of the film that we are watching. How does it manipulate concepts such as 'time' and 'space' to produce particular interpretations in the viewer? Also, from whose viewpoint is the story being told – an omniscient viewer or from the point of view of one particular character? Are we allowed inside the character's head, to hear their inner thoughts that no other character can share?

It is important to understand films alongside other examples within a genre. This is something that is the *forté* of film studies. Sometimes our perception of an earlier film is influenced by a later one. If we see something that has mocked or parodied an earlier film, it is harder to then take that earlier film seriously. We must consider the issue of genre and the shared language as well as approaches of particular genres. Certain movies try to challenge and stretch genre expectations. Another way of categorizing films

is by thinking of them as the collective output of a particular creator. In the 1950s, in French cinema criticism this approach was very important and became known as the *'auteur'* approach to film. The *'auteur'* (French for 'author) is the creative genius behind the film (usually the director). Film studies scholars spend time tracing the output of this one individual and exploring how his or her approach changes over a lifetime. Interestingly, under the *auteur* theory, actors have supreme economic and cultural power but are not seen as holding aesthetic power in the same way. This theory, first advocated by director Francois Truffaut, that the director is the creative force behind a film and that the message can be considered theirs is a controversial one. Critics emphasize that the process of making a film is a collaborative one. Others argue that the film itself should be the sole object of study in order to derive meaning and that there should be far less concern with the intentions of the director.

Related to this is the question of whether meaning is fixed because the movie will always remain the same every time it is shown or whether its meaning changes over time. As historians we are conscious that audiences bring the morals, values and priorities of their time to the film when they are viewing it. As mentioned earlier, this can happen on a personal and psychological level every time we view a film. So our own life experiences change its meaning. But it can also happen at the level of mass response to a film. Theorists view films through their own particular lens depending on their interests. So, it is possible to have a feminist interpretation of a film or a 'queer' one. Perhaps it's not possible to pin down one meaning of a single film after all.

Much of this section has focused on the motion picture, usually a rendition of a fictional or factual event with much creative license. However other types of moving image are important and historians can use the techniques learned above and ask the questions mentioned there about these other types of source. Television is another important medium providing sources of evidence for historians. Although the business model and means of production of television programmes is different from that of movies, they share many similar characteristics. Television and film can be non-fiction too, and documentaries and news broadcasts are very useful for historians. However, it is important to be careful about how you use them. Historians can use documentaries and news broadcasts as secondary sources. By that I mean that it is possible to glean information about what happened in the past. For example, if you don't understand what happened during the Battle of Britain, you can find out from Pathé news reels, just as you might read a textbook or a historian's account of the era.

However, the same sources can be used as primary evidence. This will produce related but different results, because you are asking different questions. Instead of asking 'what happened in the past', you are asking 'what did people in the past understand about the events happening

around them and why; who is manipulating their view and in what ways?' This difference in emphasis is crucial if you are to use non-fiction film and television output in an innovative manner. Again we analyse the technological aspects of the piece: how it was constructed, which shots were selected. Emerging innovative technology, such as the possibility of live broadcast, has had a massive impact on production values. But we also need to think about how such production choices affect the message we receive: whose story is fore-grounded in a particular non-fiction bulletin. The way that authority is conveyed is also interesting. Historians need to think about why a particular format is trusted. The eyewitness on the spot is a useful trope here, employed by television news broadcasters around the world.

Hopefully in this section you have understood the ways in which it is possible for historians to engage with film and the moving visual medium in general and the tools with which to do this. As with art works, historical context is everything when analysing film. And we must always be careful in our analysis. As Janet Staiger thoughtfully expresses it: 'the moving image is a document rather than a monument of the past'.[5]

Archaeology and architecture

As with films, we feel that we have an understanding of material culture and the built environment because it is all around us and permeates our everyday lives. We constantly move through historic environments that leave their readable traces and allow us to interpret the layers of the past. Just as churches, for example, are not products of one era preserved as museum pieces for all time but represent layer upon layer of theological debates, economic decisions and spiritual statements across the generations, so our built environment is just the same. The history of the last 250 years or so is easily accessible to us in our cities, towns and villages, but traces of the more distant past can be found with some probing. Material culture – the artefacts of our own history also surround us and give us an easy familiarity with the products of the last few decades, even in some cases up to a century old. However in order to analyse these goods and places as sources for our own historical writing, we have to create some distance between us and them, to try to forget the easy familiarity we have with them and instead analyse their significance to people in the past.

The issue of survival of aspects of material culture is a crucial one and one that archaeology concentrates on. The discipline is most concerned with situating an artefact in the environment and through this connection it gains a historical context. The very survival of a piece of pottery, for example, means that it is of interest to an archaeologist. Historians tend to also ask the question, what happened to those things that have not survived, the ghost artefacts that we know must have existed once but no longer

do. What explains their destruction? Perhaps their ephemeral nature is a factor, but perhaps their destruction was deliberate as they were superseded by another artefact. Perhaps a collector or a museum has preserved the surviving examples because they have been given a particular value or are considered to represent a particular creator, manufacturer or genre of goods. They might simply be a beautiful or unusual piece. It is important to think about the significance of the piece of material culture itself, but also about the significance of its survival when destruction is far more commonplace.

Let us think now about how the techniques and theories of archaeology can help to interpret material culture sources. It is tempting when faced with an artefact to imbue it with a certain sort of historical truth. Material goods seem somehow more substantial, more solid and real than written or oral testimony and must therefore be trusted. We can see them with our own eyes and absorb information about them from other senses such as touch and smell. They have come to us despite the distance in time that separates them from their creator. The challenge of understanding material culture is a big one because there is no single, agreed classification system with which to catalogue these items. Archaeological descriptions are a good place to start and help us to engage with the 'life history' of an object, as Jordanova puts it.[6] Material goods have their own visual language, just as films do. An examination of material culture can also take us into art historical territory, especially if we have a particular creator's complete work in front of us. As mentioned earlier, art history can offer us a way of describing the typologies and aesthetics of such artefacts. Archaeologists tend to be less interested in the 'who' of objects, that is in finding the creator or even the user of a particular artefact, and more interested in the 'what'. Attention is paid to the place and date of the manufacture, and the materials that were used to make it.

In this way, by examining the origins of a particular artefact, historians can think about patterns of the consumption and fashion in goods. Archaeological digs exploring colonial North American sites reveal that these nascent settlements were connected to the global porcelain trade early on in their history. While we may not be able to tell who owned a particular object, the fact that it has gone on such a long journey at all tells us something significant about markets and desirability of porcelain during this period. As we know that settlers in the early American settlements were not from the highest echelons of society, we can also tell something about the spread of the consumer revolution into middling ranks of society. So by building on archaeological methods of categorizing an artefact based on its exact location of discovery, as well as exploring the details of its manufacture, we can tell big-picture stories about the past.

Archaeology links the study of material culture with the study of place. It prioritizes not only sites of unusual activity or historic importance, such as the early American settlements just mentioned, but also sites of a seemingly mundane nature such as backyards of domestic

properties. Archaeologists enquire as to the nature of a landscape historically, whether it was agricultural or industrial, domestic or civic. The landscape that they are interested in has been altered by human activity. It is not merely the natural, untouched landscape. However, they are less interested in the formally-designed landscape. This is usually the purview of architectural or garden historians. Archaeologists measure and plot the boundaries of a particular area, whether physical, legal or social, often crucial in the history of a particular community or family. They take the physical evidence in the ground, observed by researchers with hand tools, or measured by the latest technology, and link it with archival records such as maps.

Structures, the built environment that survives above ground now is of concern to some archaeologists and also to geographers and architecture scholars. They are not as easy to 'read' as you might imagine. First, the obvious point: if you see a date mark on a particular building and assume that is its date of construction, you may only be partly right. Perhaps this building had only a few rooms or its shell constructed then, with the rest of it only being built much later. Almost all buildings are revealing of trends across multiple periods. As with material culture, the survival of buildings in the built environment also causes problems. Have the buildings surviving from a certain historical era been artificially preserved and if so why? Has our value of historic heritage ensured their survival? Alternatively perhaps they have been preserved due to their secure history in one family. Why have so few houses of low status from prior to the nineteenth century survived? The answer is of course their vulnerability to destruction (often linked to the choice and cost of building materials) and to the desires of fashion. Those that do survive can tell us a great deal about the way people in the past lived, their everyday priorities, activities considered important or sidelined (based on the room layout). They can also sometimes tell us about spiritual concerns, such as the hiding of spiritual objects in the fabric of a building.

So, buildings can be read in two ways, influenced by various disciplines. Firstly as tangible symbols of the past, which have been constructed with materiality and functionality in mind. Secondly, like other artistic endeavours, they can also be read aesthetically and their relationship to style and fashion must also be acknowledged. Architectural history has a great deal to tell the student about how to use buildings as primary sources in research. Documentary evidence, of course, is important, and architectural historians record a building using photography focusing on both interior and exterior aspects. Our understanding of the history of the built environment has also changed and architectural history helps us to interpret this. Style was supremely important during the eighteenth and nineteenth centuries, but more recently other conditions such as the state's desire to control and restrain society by manipulating town and cityscapes have come to the fore.

Conclusion

Hopefully this chapter has done several things. It has shown how other disciplines approach our source material, explained the theories and methods that historians can usefully borrow from these disciplines and raised some important questions to think about when approaching your source materials. Subsequent chapters will go into more detail about each source type, providing examples to study and showing how historical analysis might work. Before progressing, we need to make sure that we understand the possible approaches to these sources. We also need to think about what is distinct about what we do as historians too.

Key points to remember:

1 Art history teaches us how to interpret, define and categorize works of art. Film studies as a discipline teaches how to contextualize a particular film in the history of the industry or a director's output and also how to interpret its meaning. Archaeology and architectural history show us ways to analyse material culture and the built environment.

2 All these disciplines marry two approaches, an assessment of the circumstances of production and consumption of the artefact in question: exploring people, places, materials and technologies, with an assessment of the aesthetic value of the artefact itself, relating it to genre, style and fashion. Both of these aspects of the study of non-textual material have their own histories too, showing that the meaning of a source changes over time.

3 Postmodernism has encouraged us to believe that there is no intrinsic, fixed meaning of any source, whether textual or not. Reception theory, borne of an attempt to understand readers' responses to literary texts, but also applicable to visual material, now posits that every reader, viewer or spectator brings his or her own subjective view to the source, meaning that it the source's message is always malleable. Meaning does not belong to the source itself, but rather is created through the interaction between artefact and reader, viewer or spectator. One reader's 'decoding' could be very different from another's and both could be very different from that intended by the creator.

4 Historians have their own interpretation of postmodernism. They reject extreme post-structuralism and instead believe that it is possible to historicize the meaning of any source. This does not mean that it is fixed, even in a particular time period. But rather it allows us to construct a framework through which meaning can be understood and interpreted. Most historians feel more comfortable with the idea that it is possible to recover a truth about the past,

and that by accessing non-textual sources alongside textual ones we can come closer to accessing this truth by understanding the interconnectedness of attitudes and artefacts.

5 Scholars from other disciplines might not be able to agree on how to interpret non-textual sources' messages, but as Jonathan Culler has stated, a source 'does not speak, it only answers'.[7] Historians have to make sure that they are asking the right questions, and this is what subsequent chapters will help you to do.

CHAPTER TWO

Reading Images

Aim: In this chapter, we will explore in detail some of the issues that arise when historians use still images as their primary sources. We will discuss a variety of sources including paintings, maps, cartoons and photographs. The first section will begin by considering the creation of these images, the practitioners involved, the role of the state in manipulating and distorting their message. The second section investigates contemporary audience response. How does this link with the creators' intent? We look at both positive and negative, even violent responses to images from a wide range of historical contexts. Finally, we finish by considering historians' responses to images. Building on the theoretical underpinnings gleaned from the previous chapter, we will suggest ways that historians might understand images in conceptual and practical ways. We will also explore a number of case studies. If you would like to see practical ways of using these case studies and others like them in your own assignments, please turn to Chapter Five on 'Practical Applications'.

Creation of images

We begin at the beginning, with the creation of images. The three key questions here are who, why and how. (We will move on to 'what', that is, the content of an image, when we look at our case studies at the end of the chapter.) The 'who' question can seem utterly obvious or be masked by anonymity. As with textual sources, attributing a particular 'creator' to a source seems to be one of the most important things that historians do.

Without understanding who produced the source, how can we possibly interpret it and therefore use it argumentatively and reliably in our own work? However, as with a textual source, assigning a name is not enough. We have to be sure that this person really has been centrally involved in guiding the impulse for its creation. With visual images, a single creator is often difficult to identify. We have discussed previously, the example of famous artists who allowed apprentices in their studio to work on the 'great masters' paintings. We have a value system regarding visual images. Some images are prioritized as 'art' whereas the output of other 'artists' is merely their 'work'. Being involved in the 'design' process is prioritized over the 'manufacturing' process.

With other images, we also need to think about the creator in tandem with the means of distribution. By this I mean that if we take a painting that is then turned into a book illustration, via an engraver, how do we credit the original artist and the engraver? Which one has imbued the image with more meaning? Other images become important artefacts, not because of the artist, for example, a cartoonist or photographer, but through being published in a newspaper or magazine. If we are to understand the meaning of these images, we must acknowledge the role of newspaper editor or proprietor too. Just as with the films we discussed in the previous chapter regarding the *'auteur'* theory, images are rarely the sole product of the vision of one individual. They are produced through collaboration which must be acknowledged by historians. And this is before we even begin to ask how the historical context, the situation in which creators find themselves, has influenced their work.

Historians are interested in change over time and the role of creator of an image changed with the onset of modernity. Modernity is a massive cultural, political and economic development that concerns all historians of the eighteenth to twentieth centuries. Technology helped to democratize the production and the consumption of images, as we'll see later in this chapter. John Tagg, who studies the significance of the development of the photographic medium, argues that the 1888 Kodak camera completely changed the relationship of ordinary men and women to images.[1] The reason for this was that it made it possible for individuals to take pictures of themselves, their families and their surroundings without the need for a professional photographer. Prior to that, the size and expense of cameras meant that only a few people could afford them and that they were not easily transportable. This ability to design, take and be present in one's own photographs changed the ways in which people constructed their own identity. Tagg was writing a generation ago, before the development of social media. Had he been aware of twenty-first-century developments, he would have drawn very interesting parallels between the coming of the 1888 Kodak and the use of the 'camera phone' to take 'selfies'. This is another example of a new technology changing the way that everyone

relates to a particular type of image. Of course, prior to the arrival of the 1888 Kodak, subjects of photographs and also of paintings were still able to manipulate images of themselves for their own ends. They were still concerned about self-fashioning, as will be seen later. And this is another important reason for being very subtle when thinking about the 'who' question regarding images. Sometimes, the subject of an image has as much creative input into the construction of that image as has the supposed author or artist.

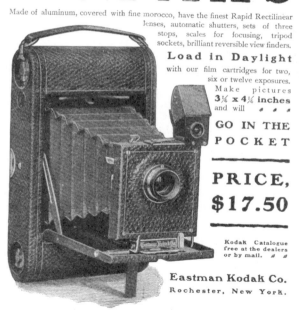

FIGURE 2.1 *Advertisement for Kodak Folding Pocket Camera 1900,* Outing, *Vol. XXXVI, No. 5, August 1900. p. xxix. New York: The Outing Publishing Company. Public Domain.*

Purpose of image creation

Let us move on to consider other ways in which images are controlled and distorted, addressing the second of our three key questions, the 'why' of images. Thinking about the purpose behind the creation of images can help us to interpret them. The role of the state is crucial in many cases. Photographs have been used to illustrate and to entertain but also to control and define. Since the invention of the camera, photos have been considered an accurate representation of the reality that they depict. There are many problems with this perception, as will be shown later. But for now, it is enough to understand that towards the end of the nineteenth century, the potential of the photograph to document certain types of people became one of its key purposes. From that point onwards it became linked to surveillance and record keeping. These sources are not neutral. Their purpose makes them part of networks of institutions of power and control such as the hospital, asylum and police force. Following theories of Michel Foucault, these photos become complicit in objectifying the bodies of those marginalised by society: the criminal, the orphan and the insane. By keeping these records, nineteenth century authorities thought that they could better understand and control the behaviour of those depicted. Such objectification was undertaken in the guise of supporting social Darwinist theories that mental characteristics governing criminal behaviour and insanity could be predicted by observing and measuring external features. The pseudo-science of phrenology* was maintained and enhanced by the use of photography. These archives of photographic material are available to researchers in the twenty-first century because the state thought it appropriate to keep records of the images of these marginalised groups. So, in a sense researchers are rendered complicit if they thoughtlessly use such images.

Attempts to use images to control people and places on a national scale are also revealed in the study of the reasons behind the manufacture of maps. We might imagine that the map is a realistic portrayal of a particular landscape, albeit one that employs particular symbolic conventions recognized by all. This is not the case, and maps reveal manipulated and distorted impressions of the landscape and have done so since their conception. The question that should be asked of a map is not whether it accurately depicts the landscape it represents but why has the mapmaker chosen this particular way of depicting the region. Control via the medium of the map has been exerted by many societies round the globe, China among them. Maps can be used

* Definition: the belief that the dimensions of the cranium reflect the characteristics of the individual.

to symbolically claim territory in newly explored lands. They do this by putting the conquering nation literally 'on the map' through, for example, place names, in a particular language. The earliest maps of colonial North America used Native American names for settlements, rivers and regions that were learned by English settlers such as John Smith. But very quickly, within a matter of a few years, the incomers had grown in confidence and they used their maps to convey new naming practices, not simply adopting Indian names but renaming landscape features and settlements with English titles. This trend continued throughout the duration of the British Empire as maps of the globe reinforced the sense of national unity and imperial control. Maps grew in importance as nationalism developed in the nineteenth century.

Apart from renaming and claiming, maps changed the way that entire countries and regions were depicted in order to suit their creators' purposes. In the twentieth century, both Nazis and communists perceived the propaganda value of maps and made deliberately manipulative choices when depicting their worlds. Even today, standard maps of the world present the land masses of the world in a distorted fashion, artificially enhancing the size of Europe and other northern hemisphere regions to the detriment of the southern hemisphere. Challenging this phenomenon are equal area map projections, such as the Peters or the Hobo-Dyer, which depict Africa and South America to their true proportions, the importance here is not that these maps are more accurate, but that the standard projection still reflects the Euro-centric, imperialist aims of certain nations. These maps make Britain look larger and therefore more significant and dominant. Have you ever considered why Britain is depicted at the centre of maps of the world? Your eye is naturally drawn to it and the rest of Western Europe and it appears metaphorically at the centre of the world. If we move back in time to the Medieval *mappa mundi*, the centre of the world is often Jerusalem. There is more on *mappa mundi* in the case-study section at the end of this chapter. These maps were displaying control and empire of a different kind, the spiritual empire of Christianity. Because they depict the entire Christian world, unusual aspects appear on them, such as the location of 'paradise'. These maps are not aiming for a realistic depiction of the natural world but rather aim to tell the viewer about the spiritual world.

Maps are not only about the way that land masses and geographical features are depicted. Until the eighteenth century, maps were highly illustrated and the peripheral material must also be understood if we are to answer the 'why' question about maps. Later maps employ such tools as scales and a compass to add authority and the weight of scientific accuracy to the map. But earlier maps use other tools to claim authority. The coat of arms of the patron whose sponsorship allowed the creation of the map is often prominent. More metaphorical ways of claiming authority

are also present, employing classical tropes of the monstrous races taken from Pliny's *Natural History* to suggest 'our' understanding of 'the other'.* In this way, ethnicity appears on early maps. However, some early maps acknowledge the lack of knowledge of the mapmakers. When depicting regions as yet not surveyed or even visited, early map makers left a blank space in the map, showing not only the lack of knowledge but also often using symbols to depict its rumoured potential, through, for example, the positioning of animals in this otherwise uncharted territory. These animals were not meant to put off potential visitors or settlers but rather designed to entice them with opportunities of hunting or trade. As you can see by this, maps are far more complex than the simple depiction of the natural world that we began with.

Maps have also been used historically as teaching tools. A particular type of map, the 'dissected map' predated the jigsaw and served a similar purpose. They were published from the late eighteenth century onwards as didactic** tools, targeted at very wealthy educational institutions or families. The maps were broken up into several pieces and children familiarized themselves with the map of the world through piecing it together. Through these maps, children also learned about the importance of their own region, nation and empire and were taught moral values such as the supposed superiority of the British. The earliest examples of these maps were of amateur manufacture, meaning that the maps were printed as whole sheets to be used normally, but were then cut up afterwards for educational purposes for children. Later on at the turn at nineteenth century, publishing firms such as John Marshall produced dissected maps of England themselves, as part of their children's miniature library collection. These artefacts cross the boundary between books and toys and show the development of new Enlightenment educational theory influenced by Locke and Rousseau.

Maps intended to be public documents, proclaiming possession or encouraging exploration, are complemented by documents with a very different purpose, the secret map often with military significance. Many of these maps are in manuscript and were only printed at a much later date. Their format is important. Maps that were printed, often at great cost to patron or publisher, were seeking a wider audience. Those remaining in manuscript had another purpose, to guide a small number of travellers or to give confidential information about, for example, the whereabouts of enemy troops or the strategic strength of particular ports.

The state is not the only manipulator of images that historians need to consider. Advertising has existed ever since the marketing of commodities

* 'The other' in this context refers to the metaphorical alienation of people from other races and religions – a common practice throughout the Renaissance and into the modern era.
** Definition: having an educational purpose with moral overtones.

began and the visual has worked alongside the textual as a means of attracting attention to the seller and their product. Sign boards in medieval European towns drawing attention to particular shops and traders, now existing only in the form of those advertising inns, taverns and pubs, are an interesting type of the visual medium. Although not a formal advertisement in the way we understand the term today, these boards give particular vendors certain characteristics, associating them with, for example, local or national pride, a particular royal or aristocratic patron or commemorating a certain event. These signs also acted as location directors in a time before the existence of street addresses, allowing purchasers to negotiate their way through crowded urban streets to find a particular shop.

Advertising in eighteenth-century and early nineteenth-century newspapers and magazines relied for the most part on textual detail, with some advertisements appearing at great length with complicated testimonials from satisfied customers. Images were occasionally used, but these served more to break up large sections of text, to attract the reader's eye to the advertisement rather than to persuade or to complement the text in any specific way. From the late nineteenth century, however, as advertising as an industry, especially in the United States, took off, images began to be used more frequently and in the twentieth century the visual language overtook the textual in the importance and centrality of its advertising message. By the latter part of the century, it became common for images to appear text-free in advertisements, so iconic and ubiquitous had some aspects of the visual commercial language become.

So, how do advertising images work? How do they manipulate the viewer? Images are a more effective way of advertising a product than a detailed testimonial because they are subtle and work insidiously on our psychology. Subliminal techniques were mastered during the early twentieth century and at that time there was great concern over the manipulative power of advertising and the vulnerability of audiences, especially the lower classes and later of children. Advertising became an industry of its own at this time; no longer did companies manage their own advertisements but instead they farmed out this aspect of their work to 'ad-agencies' who focused solely on sales and marketing. The attitudes and emotions of viewers in relation to particular products are altered most successfully in advertising by changing or reinforcing the way that viewers feel about themselves. Aspirational branding makes people believe that they can change their character, lifestyle and mental well-being simply by purchasing, owning or consuming a particular product. It does this by displaying recognizable images that viewers are familiar with and that they will react to emotionally rather than rationally. An example of this is the iconic 'Marlboro man', used to advertise Marlboro cigarettes in still images and in film and TV adverts. The imagery only subtly focuses on smoking, which is peripheral to the message of rugged masculinity through the depiction of the US cultural icon, the cowboy, and of the vast,

untouched Western landscape that typifies the United States. In 1954, advertising agent Leo Burnett was tasked with attracting male smokers to the brand and he created the campaign that lasted for nearly half a century. In the later twentieth century, the campaign also transcended growing health concerns about smoking and allowed Philip Morris, the company that owned the Marlboro brand, to maintain its profits.

As mentioned earlier in the chapter, self-fashioning is another important way in which images are manipulated by their creator or their subject. Portraits, whether paintings, drawings, sculptures or photographs, are often as much a creation of the sitter as the artist, especially in situations where a patronage relationship distorts the possibility of artistic freedom. When subject and artist are one and the same as with twenty-first century 'selfies', the dominant mode is the control of the message. Manipulation of digital images is something that we are used to. We are aware of the phenomenon of 'airbrushing': the alteration of an image to improve the look of the subject using digital photo-editing software such as Adobe Photoshop or Illustrator. It is also possible to easily crop such images digitally whereas previously, editing photographs would have required some expert knowledge.

Prior to the nineteenth century, the only classes in society able to have their image recorded in portrait were the aristocracy and increasingly, in imitation of them, the middle classes. The cost of patronising an artist was prohibitive to the majority of people, and the messages of authority and identity that a portrait conveyed were not part of the outlook of most of poorer people. This does not mean that occasionally portraits of the lower orders were not painted, such as those of the jester, but these were undertaken at the behest of the masters, for the continuing entertainment of them and not on behalf of the jester himself. The jester, the joker or the fool was a stock character and figures on everything from tarot cards to playing cards, and this sort of symbol must be understood for its non-specific, metaphorical attributes too. Jesters can symbolize folly, distraction or even honesty as part of the human condition rather than depicting a particular individual. Emblematic use of imagery such as the medieval 'ship of fools' also reinforces such interpretations, showing how those in authority maintained their position in society by 'othering' or distancing themselves from fools.

Rulers throughout history have made use of the portrait to tell their audience something about their rule and character. They often used imagery to depict an ideal version of themselves, although Oliver Cromwell specifically told his portrait painter, Sir Peter Lely, to depict him with 'warts and all', which Lely then did. Cromwell, however, was cleverer than he might at first seem. He was willing to be seen with all his facial blemishes because he knew that this was a way of distancing himself from the corrupt absolutism of the regime that preceded him. He wanted to be seen as a man of the people, not as a distant, superior authority figure. Monarchs

before him had used imagery for their own ends, to convey the sense of their physical dominance, as in the case of Henry VIII; or their loyalty to country, as in the case of Elizabeth I; or their masculine prowess, as in the case of Charles I. Charles's portrait is an excellent example of the use of iconic imagery to conjure up overtones of imperial and monarchical dominance. Charles did not lead his soldiers into battle and indeed was not a keen horseman at all, but by Anthony Van Dyke depicting him on a horse in several paintings, Charles tapped into viewers' assumptions about leadership and horsemanship that date back to the ancient world and Argive pottery from 700 BC when the horse-backed leader figure was regularly depicted. Charles's portraiture disguised his diminutive size and presented him as the ideal leader.

There were many other reasons why images for the manipulation of images by their creators and this further reinforces the reason why it is vital for the historian to approach them with a degree of scepticism. Do not believe what your eyes tell you. This is especially true of photographs in which we assume that there is a sense of truth, an assumption that we are seeing what is really there. There are generally two types of photographic composition, the posed and the natural. Of course we understand that posed pictures are fashioned in the ways that we have previously discussed. However, even the seemingly natural photo capturing an unprepared scene must be treated with caution. Objects, people and settings can be arranged and changed to reflect the requirements of the photographer, and the shot selected, and lighting and shutter speed have been chosen with an effect in mind. War photographs, even from the very earliest days of photography, were manipulated by journalists who wished to convey the horror and tragedy of war and yet did not have an appropriate scene before them. And so they created it! Deceased soldiers were moved in order that shots of them in different 'death scenes' could be constructed. This is redolent of the twenty-first-century example when Fabienne Cherisma's body was moved by photojournalists during the chaotic scenes in the wake of the Haitian earthquake. We will discuss this case study later in the chapter. Photos might also be entirely faked, not depicting what they claim to. Heated debates rage about the veracity of certain images. An example is the famous picture from the Spanish Civil War, showing 'The Falling Soldier', taken by Robert Capa supposedly in September 1936, and depicting the death by gunshot of a republican soldier. The picture became part of Spanish Civil War iconography and was published around the world, including in the United States in *Life* magazine. Biographers of Capa have never found the negative and are unable to prove whether the image was faked or not. Does this mean that we should abandon this photograph and proclaim it historically useless? No, because it has important historical resonances whether staged or not. Its fame and notoriety have imbued it with meaning.

Contemporary audiences

As we've seen with the construction of photographs above, it is impossible to separate the creation of images from the role of an audience. The viewer, observer and seer, whether individual or collective, is imagined in every act of creation. This is true for artefacts and for textual sources too. How we understand an audience is crucial. We must be subtle. As historians, we know already that audience response is historically contingent, that it changes over time. Our understanding of an image is likely to be very different to that of viewers seeing the image when it was first created. This is because we have different cultural baggage: so we understand the world differently. We have different ways of interpreting the symbols, colours and shapes. We are viewing with hindsight and so we have a broader more analytical understanding of the context of the creation of the artefact. We have distance from it. We also view it intertextually, linking it with all similar genres and modes of representation that have emerged since. We may be aware of later parodies that contemporary viewers would not have seen. Also the very act of viewing an image is coloured by how we imagine the 'viewer'. Audience is a collective word: it suggests that it was aimed at a number of like-minded people who would share a similar response. If we discuss the single 'viewer', indeed a much more subjective concept of the audience, the individual is relating that image to his or her personal experience. Is such a response measurable, as it is different in every individual, perhaps different, too, every time that individual views the image?

This is further complicated when we introduce economic relationships into the audience perception. What happens when the viewer is also an owner, a buyer or a consumer? Does this change his or her response to the piece? As historians we need to try to understand the influence of the market for consumable goods, such as prints, and its response to audience demand. The interplay between the creator and his market is a complex one. Neither the creator nor the audience is the sole driver. Originality and so-called 'genius' is quickly imitated and what Jordanova calls 'derivative forms' are produced at a price to suit the market. The medium is responsive to the market.[2] But it would be wrong to imagine an audience as a single homogenous entity. There are always multiple, diverse audiences whose responses often challenge the creator's original intentions. How can we categorize audiences? Sociological markers can be useful starting points here and we must think about issues of race, gender and class as a means to define the response of audiences. Sometimes these basic identifiers are not enough and other categories can be introduced, such as political persuasion and religion.

Exploring the way that audiences respond to certain types of images and imagery is fruitfully enhanced by examining a religious context. It can reveal the most polarized responses to a single image, ranging from

idolatry to iconoclasm.* Religious images are imbued with a particular kind of power and authority given to them by their style, genre and positioning in religious settings, but even then errant readings are possible. In the medieval period, images of all kinds were believed to hold a special type of power over the beholder. Pregnant women were forbidden from viewing paintings considered ugly or of dubious morality for fear that her child would be tainted in the womb and would be born deformed. Men sentenced to death were shown edifying images, known as *tavolucci*, just before the moment of death to encourage them to achieve full repentance.[3] Religious images held the most power and were given that power at the moment of consecration when a mere thing was turned into a sacred vessel which might act as a conduit between this world and the next. In the Catholic tradition, images and relics had similar functions. They were no longer mere objects, creation or remnants of man, but rather actual vessels of holiness. Just as the bread and wine in the sacrament become the body and blood of Christ in the Catholic rite, so relics and images are not only symbols of holiness but *are* holiness themselves.

At the Reformation, the relationship to religious images and artefacts changed fundamentally within a few years. Protestants do not believe that relics and images can literally become sacred but rather that they encourage pagan-like idolatry, the worship of a thing rather than of the true God. In a period of a few short years during the reign of Edward VI in England, many churches were stripped of their images and artefacts that were no longer accepted in the new religious atmosphere. In some cases, images were carefully preserved, put away in private homes, waiting for the day when hopefully they could be restored (as indeed did happen in England briefly under Catholic Queen Mary I). Others were sold at great profit to the church. However, in many cases, then and in the mid-seventeenth century when a further outpouring of iconoclasm took place, images were not carefully removed or sold but were defaced or destroyed. The word 'de-faced' is appropriate here; it is the face of a portrait, a monument or a sepulchre, for example, the one in the Cathedral of St Martin at Utrecht, that was damaged during the period of Beeldenstorm (literally 'statue-storm') driven by the Calvinism of the 1560s. Here, the iconoclasm was supposedly organized and orderly (as befitting a Calvinist 'revolution'!) but realistically the authorities were not able to control ordinary people and their defacing of statues reveals a much more personal response to the images. It reveals the power of the image. If it had not held power, it would have been ignored, neglected or simply removed and sold. Iconoclasm reveals an emotional response of anger and outright hostility to the image and a desire to obliterate its symbolic meaning to that person

* Definition: iconoclasm is the destruction of religious images because they are perceived to be heretical.

and that community. It was not only religious images and statuary that were vandalized in this fashion but tombs and monuments as well. Tombs and monuments within a church are an excellent subject of study for the historian. We can think about the way that the individual or family chose to fashion themselves in a particular religious context, using certain genres and styles of memorialization. Husband and wife depicted side by side, but not touching for example, gradually being replaced by memorialization showing a more loving attribute. Tombs also show changing attitudes to death, but the viewer response to such tombs has varied. At the Reformation, some tombs of religious figures such as bishops were desecrated due to being sites of pilgrimage and perceived idolatry. We must also be realistic and state that some iconoclasm took place for more cynical reasons, attempts to make money from goods secreted in tombs or from images themselves also motivated many who removed images from churches at this time.

Iconoclasm is not a solely religious phenomenon. Political, secular iconoclasm undertaken by mass popular movements or by the subsequent regime has been common throughout the twentieth century. The removal of the statue of a previous ruler during a revolution has become an icon itself, this time not an icon of power and authority as the statue once was but an icon of change. It is an attempt to symbolically erase someone from history, by removing their memorial, a practice dating back to Roman times. Joseph Stalin was a prominent practitioner of the iconoclasm of images, doctoring photos so that those party officials who had fallen out of favour and had been executed were removed from pictures with Stalin. It was as if they had never existed.

Such extreme responses to images do not tell us the whole story though. Defacement or destruction is not the only way in which audiences responded passionately and violently to particular images. Cartoons are another significant genre of image that elicits strong feelings among their viewers. Many images are produced to entertain, to titillate or merely to illustrate textual material. Cartoons have a dual purpose, both to make people laugh and to contribute to political debate. They use humour, exaggeration and satire to challenge our political beliefs. There is no such thing as a neutral cartoon; it always has a particular message. But historians need to be focused when trying to work out what the audience response to a particular cartoon was. Many cartoons are radical, even shocking, but soften the blow with humour. Complicated political and philosophical ideas can be conveyed, for example, through the use of personification of 'liberty'. It makes these ideas more accessible to a broader audience, although cartoons are not the only genre to use such personification, as we saw from our discussion of maps above. Are we to understand that the audience already agrees with the cartoonist and shares his or her political views or that the cartoonist is intending to provoke change in the viewer? Or to put it in the terms of Italian theorist Antonio Gramsci, at what point can the cartoon be considered hegemonic? When does it become the

FIGURE 2.2 *Iconoclasm at St Martin's, Utrecht, photographed in 2003. Public Domain.*

dominant cultural form? At what stage is it speaking from the point of view of the rebel or the one in authority? As Frank Palmeri has argued, all cartoons, even if conservative politically or representing the view of those in authority, are still reflecting an attitude of violence and indignation.[4] A good example of this is the work of Frank Beard, a cartoonist working in

late nineteenth century United States, whose work was published in the Christian periodical *The Ram's Horn*. Beard's main motivation was a fear of secularism and many of his cartoons promote a non-denominational Christian message. He commented on votes for women, on temperance and on the key issues of his time. In the 1890s, he drew several cartoons from the Nativist point of view, that is someone resistant to immigration and who often held anti-semitic, anti-socialist opinions. He felt that images told a story more quickly than words and made his moral tales more available to a wide audience. Regarding audience response, the cartoon depicted here would have elicited nods of agreement from many of its viewers, reinforcing their concerns and perhaps rousing some to action. There is certainly an undercurrent of violence present here. However, Beard's view was that the prevailing attitude among the ruling classes was one of laxity towards immigration and he saw himself as fighting a rearguard action against this tolerance before it destroyed the nation. Cartoons rarely appeared without accompanying text and although some of the audience may have been semi-literate or illiterate, many viewers' understanding was enhanced by the reading the words alongside the image. Beneath Beard's 'Stranger at the Gate' image were the words:

> *EMIGRANT. – Can I come in?*
> *UNCLE SAM. – I 'spose you can; there's no law to keep you out.*
> *DURING four hundred and more years this continent has been the melting pot for the population of the Eastern hemisphere. For three-fourths of that time the yearly infusions of raw metal was so slight that it was not hard to compound them with the native stock and preserve the high character of American citizenship. But when alien immigration pours its stream of half a million yearly, as has been frequently done during the last decade, and when that stream is polluted with the moral sewage of the old world, including its poverty, drunkenness, infidelity and disease, it is well to put up the bars and save America, at least until she can purify the atmosphere of contagion which foreign invasion has already brought.*
> *Stand in the gate of the Lord's house, and proclaim there this word: Thus saith the Lord of hosts, the God of Israel, Amend your ways and your doings, and I will cause you to dwell in this place.*
> *Jer. 7:2–3.*

Historians' responses to images

Early twentieth-century art historian, Erwin Panofsky, provides us with an excellent three-part theoretical framework with which to interrogate images and elicit meaning. 'Interrogate' is a good way of thinking about what historians do because Panofsky was a keen fan of Arthur Conan Doyle's

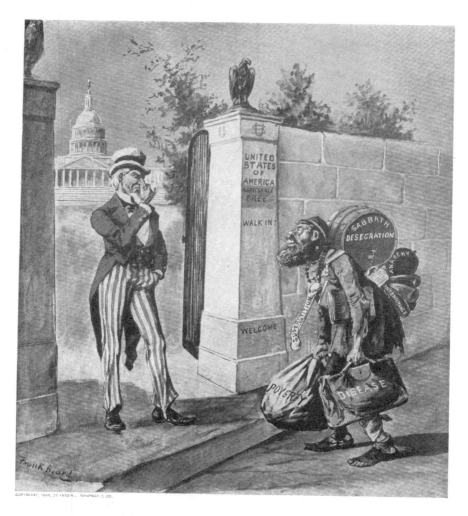

THE STRANGER AT OUR GATE.

EMIGRANT.—Can I come in? UNCLE SAM.—I 'spose you can; there's no law to keep you out.

FIGURE 2.3 'The Immigrant: The Stranger at Our Gate', Frank Beard, 1896.
©Billy Ireland Cartoon Library 2015.

Sherlock Holmes mysteries and saw his own work in reading images as akin
to Holmes's in reading clues! It provides the basis of what I argue is the best
way to approach images.

The three layers of meaning that Panofsky refers to are firstly the
'natural', asking the viewer what is it that you see. It is a purely descriptive
level of interpretation. At this stage, you might describe colours, shapes,
textures, but you also relate what you see to reality. What is this image

trying to depict? Is it a man, an object, a pattern? Ever since 1928 when Rene Magritte told us that 'this is not a pipe' in the caption accompanying his picture of a pipe, we are aware that the depiction is not actually 'the thing itself' but a *representation*.

The second layer of meaning is the 'iconographical' level. This means that the viewer, you, brings to bear all of your cultural knowledge about images. For example, if you see a seated, innocent-looking mother holding a child on her knee, and both have golden halos above their heads, you will immediately think of 'the Madonna and Child', even without needing to see the title of the painting. This layer of meaning must be historicized too. As historians we know that meanings change over time, and by knowing the date of a work of art we can better interpret this level of meaning. Images and their symbolism, their iconography, change over time and we must be aware of this. It can help us to consider the tricky conundrum of changing audience response. Panofsky would have probably preferred that we do this without extra materials and focus on the image alone, but as historians we are happy to use allied resources.

The third and final layer of meaning is the intrinsic 'iconological' meaning. The difference between iconographic and iconological for Panofsky is clear and I think it can help us interpret images in a more precise way. It asks the 'why' question. This layer of meaning wonders why an artist chose to depict his subject in this particular way. What was it about his cultural and historical context, and that of his studio, his patron and his audience that made him craft the image in this way? As you can see, this third level of interpretation really helps the historian access the sort of meaning that we are interested in. These three layers of meaning may be summarized by the following three questions, all of which must be asked of any image. First, what do you see? Second, what does what you see mean, and how has that meaning changed over time? Third, why does what you see appear this way?

You'll notice that we are *not* asking the question about whether this image represents a particular historical reality. Historians understand that images, like textual sources, do not simply portray unmediated an aspect of the past. Therefore, even when looking at photographs or documentary film-making, do not assume that they depict a particular aspect of reality from the time in which they are made; they don't reflect without alteration events and people of the time but rather they distort reality in some way, because of the choices made by their creators. Do not be frightened by this! As Peter Burke has said, it is this distortion that most interests historians.[5] It reveals to us the cultural significance of these sources, allowing us to access the interior lives of people in the past. It brings us as twenty-first-century scholars closer to our subjects of study by allowing us to see the basic humanity of people in the past. But it also distances us as we realize how different their values and attitudes and experiences are from our own.

The power of photographs especially is very pronounced in today's culture. We assume that they have a particular authority that is not ascribed to other images. Their realism value, that is their relationship to reality, is challenged far less than in other cases. However, as we'll see later when we examine our case studies, it is important to recognize the choices and manipulation, the selectivity that resulted in the availability of that particular image for its audience. Even iconic images, such as Dorothea Lange's 'Migrant Mother', were constructed by the artist to serve a purpose. These images are not simply accidental or spontaneous, the result of an impulsive capturing of the perfect message for that moment. That photo, as we will see, was a deliberate collaboration on the part of artist and subject to depict a politically loaded scene. Photographs are everywhere in our culture, so you might imagine that students should be much better at 'reading' them than, say, early modern court records to which they have only rare access, and which are written in specific and stylised prose. But this is not the case. The analysis of photographs presents terrible problems for the historian simply because we are so used to accepting them as representations of a reality. We are actually illiterate when it comes to understanding photographic images. Hopefully this chapter will allow you to become well-versed in their use as historical evidence, and it will also consider the important ramifications of using photographs and film in your own lives to document and publish 'your history' online.

Another way of interpreting the 'realism' versus 'representation' dilemma is to think about the work of theorist Roland Barthes. His work in cultural studies since the 1960s has been vital in encouraging the separation of analysis of the medium and of the message. Barthes's understanding of photographic realism is that we can never transcend the overwhelming truth that 'the thing is there'. This is why we find it so challenging to be truly analytical when looking at photos. This belief is unusual in Barthes's thought. He felt that every other medium used representation to distance the viewer from 'reality'. But Barthes argued that photographs were unique. He realized that photographs also had the ability to blur chronological time. Looking at images of his late mother, he found it hard to position her existence in time. He decided that the message of the photograph is actually that 'the thing was there'. But John Tagg argues, we must remember that photographs are never neutral. He writes of the relationship between photography and historical study: 'photographs are never evidence of history, they are themselves historical'.[6]

It is also important to think about the way that photography and memory relate to one another. Is our memory of recent events coloured by the ubiquitous nature of the images about the topic? Are we distanced or moved closer to understanding the events of 9/11, for example, by presence of images of the aeroplanes crashing into the Twin Towers? Photographs and their relationship to disaster and tragedy have a long history. An early example is the depiction of extreme poverty in the photographs

of Jacob Riis, a progressive journalist in the United States of the late nineteenth century. His aim in photographing living conditions of New York slums, especially the notorious Mulberry Street area, was to bring about government intervention and social improvement in the tenements. His work was technically innovative at a time when flash photography was in its infancy and it impressed future president and fellow progressive, Theodore Roosevelt. Despite being an immigrant himself, critics lambasted him for his supposedly negative attitudes towards certain immigrant groups, but still Riis's work influenced subsequent campaigning photo-journalists from the Great Depression onwards.

Photographs of disaster and tragedy appear regularly in all forms of media, whether print or online. The effect on us can be psychologically numbing. Perhaps the first time we see extreme poverty, violence or degradation it shocks us, but subsequently, the effect is lessened. Thinking about the construction of photographs can give us back that sense of shock as we realise that our emotions are deliberately manipulated by photographers. A good example of this from recent history in 2010 is the photographing of the deceased Haitian teenager, Fabienne Cherisma, during the violent aftermath of the Haitian earthquake. She had been shot dead by police, supposedly for looting, and her body was photographed, allegedly where it fell, before her family were able to collect it. Perhaps more shocking than the death of this young woman and her vulnerable body depicted in the rubble of her community, was this second image of Fabienne, showing the collection of journalists who were photographing her. It makes us feel profoundly uneasy, as though we are complicit in the objectifying of Fabienne, robbing her of dignity. We the viewers support the system in which white male journalists roam around the streets of Haiti, waiting for 'an opportunity' such as this. It makes us wish that we were there to cover her up, to protect her from the world's prying gaze, to return her to her family and to tell the story as she was in life and not only in death.

When using maps, as we shall see below with the example of the *Mappa Mundi* of Hereford Cathedral, we must avoid asking questions that merely relate the map to the 'reality' of the geography of a particular place. Maps have always been used by historians to depict change over time showing, for example, how knowledge of different parts of the globe emerged during the early modern period. Space and time come together on the map. The sense of place relates to a particular snap shot of time, and thus it can be easily historically situated. Historians must learn how to interpret the language of the symbols and shapes on a map in order to position it and understand the power structures it depicts. Questions to ask include whether the map reveals an imperial, national, regional or local identity and the answer to this question must be historically situated, for example, post-Enlightenment or as a product of modernity. Questions to ask of a map include: What is

prioritized at its centre? What is missing? Who is it made for and why? How was it made? Some of these questions cannot be answered simply by gazing at the map waiting for answers to jump out at you. You must research its creation information using separate texts, perhaps looking at the details of the book in which it was first published.

But in order to understand the meaning of a map, historians must ask similar questions to contemporary viewers. In fact the whole point of a historians' reading of the map is to try to access contemporary viewpoints. However, when viewing other types of image, historians deliberately try to distance themselves from the contemporary audience response in order to better interpret the source. History is sometimes considered a science, a discipline in which a dispassionate rational observer assesses their subject's behaviour and looks for patterns and trends. Historical research is much more complicated than that, with most historians acknowledging that flaws in the source base and the subjectivity of the scholar change the relationship between the subject of study and the researcher. However, in order to better interpret the significance of some images, it is vital that the historian distances him or herself from the image to prevent the types of emotional responses that would affect the historical method. Two of the genres of image for which this applies are lynching postcards and pornography, one a specific artefact relevant to a particular time and place, the other ubiquitous in human history.

The lynching postcard is a specific type of photographic postcard produced in the early years of the twentieth century when the phenomenon of lynching African-Americans was at its peak. The lynchings took place frequently, not only in the southern states but across the United States, and they were framed as quasi-judicial executions of a black man (usually a man, although occasionally women were victims of the lynch mob) accused of a 'crime' against a white person. That so-called crime could be as minor as a supposedly impertinent glance, smile or comment. Other lynch victims were accused of theft, rape or murder, but no judicial process had been followed to ascertain their guilt. The victim would be executed, usually by hanging, but often with accompanying mutilation or burning of their body either before or after death, in a public place attended by a large, mostly white crowd. This execution served two purposes: control of the black population through fear and entertainment of the white population and reinforcement of their sense of racial superiority. Public execution was nothing new, of course, nor was the celebration of it as entertainment and theatre. This had been a mark of European society since the medieval period. In the Western United States, people of all races were lynched during the mid to late nineteenth century during the settling of the West before a rigid system of law and order could be imposed. However, Jim Crow-related lynching took on a particular racial tone. The postcards printed and produced

immediately during the lynching and its aftermath mirror the execution broadsides of earlier times. They served as a souvenir for those attending the lynching. It illustrates that many in the audience for the lynching had no sense that what they were doing was wrong and that they were proud of their attendance. But these postcards served another purpose and were collected at the time and since by campaigners against lynching to illustrate its horrors and to change the minds of those in authority who tolerated the lynch mobs and refused to put a stop to them.

It is vital that historians working with these postcards preserve and understand their own visceral response to them. The images are often extremely explicit, both sexually and in terms of the violence done to the victims. I do not want to suggest that the correct response of the scholar is to suppress his or her natural revulsion. But such a response is so different to that of many contemporaries that historians must make an effort to understand the mentality of the time that allowed otherwise normal people to accept such behaviour as normal. Was it a collective madness?

Pornography is another very emotive subject. It has existed since ancient times in many forms, not just as images. It ranges from the artistic to the hardcore and it is also historically specific. For example, Victorians considered material titillating that in today's culture is commonplace and not shocking at all. Pornography can be legally defined by what is acceptable and, of course, this also changes over time and place. The modern concept of pornography is only a recent invention and since the 1960s has been frequently considered degrading or exploitative by feminist commentators, but erotic material was present in many historical contexts. The subject matter can also vary: sexually explicit material is most often considered pornographic but individual responses can mean that materials from the extremely violent to the mundane can be included in the category. Historians of pornography deliberately do not respond to imagery in the same way as their contemporary audience, although they must have some understanding of their audience's point of view. Historians are also interested in the way that contemporaries used pornography. As with other aspects of print culture, the mass market for print in the nineteenth century changed the nature of its distribution. Erotica developed from being the sole province of wealthy men who collected art and illicit prints to being a cheap, mass market artefact as daguerreotypes, photographs and then postcards allowed the frequent reproduction of such images. Often these images were imported to other countries in Europe from France in the mid-nineteenth century (and were known euphemistically as 'French postcards') before a local industry emerged in the latter part of the century. Just as the pornographic industry mirrored the more conventional print industry, a similar thing happened with the emergence of magazines, films and later the internet. An illicit black market pornographic trade developed as the media became technologically more sophisticated.

Conclusion: Points to remember
and use from this chapter

Before we look in depth at some practical examples of the ways that historians can use images, let us remind ourselves of the most important points from this chapter.

1 The status and significance of the creator of an image is often contested and changes over time.
2 Technological developments change the way that images are produced and also change the audience and meaning.
3 The meaning of images can be manipulated by individuals and groups other than the creator. The state does this. Collectors and archivists often have value-laden purposes.
4 Images can be used by the subject to 'fashion' an identity.
5 Even photographs do not represent pure reality.
6 In order to interpret an image, the student of history must understand the visual language used.
7 The student of history must also understand what is different about his or her viewing of the image compared to other viewers, at the time the image was produced and since.

Case Study One: 'Edward VI and the Pope'

The name of the artist and date of this painting are unknown. However, this does not mean that we should dismiss it. We know that it was painted around 1570. The picture is known as 'Edward VI and the Pope'. This painting is an allegory of the Reformation and it does not depict a real event. Henry VIII is on his death-bed and is pointing to his successor, his son, Edward VI, symbolically passing his authority to his son. Surrounding the bed are Edward's guardians and council, including the Earl of Bedford, the Dukes of Northumberland and Somerset and Thomas Cranmer. All these men were known for their Protestant sympathies. Along the other side of the table sit three less easily identified men. The tonsured priest might be Bishop Cuthbert Tunstall, a sympathiser with the Catholic party who had acknowledged Henry as head of the church but regretted further moves towards Protestantism, flanked by two supporters, of whom one is reaching out nervously towards the Pope regretting his fate.

Under Edward lies the pope, squashed by the Bible in English falling on his head. The Bible is open at the words 'The Word of the Lord Endureth Forever' – crucially written in English and not Latin. On the Pope's alb is written 'All Flesh is Grasse', a quote from the Biblical book of Isaiah, on

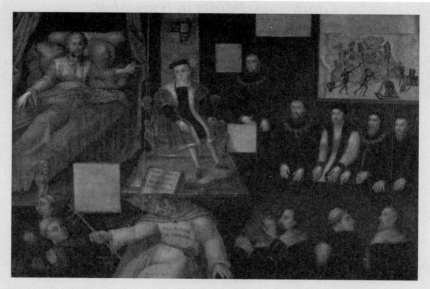

FIGURE 2.4 *King Edward VI and the Pope (includes John Russell, 1st Earl of Bedford; Thomas Cranmer; King Edward VI; King Henry VIII; John Dudley, Duke of Northumberland; Edward Seymour, 1st Duke of Somerset).* © *National Portrait Gallery, London.*

the transitory nature of human life. Words next to the Pope read 'idolatry', 'superstition' and 'feigned holiness', showing an important example of the relationship between words and imagery in painting, leaving the viewer in no doubt as to the religious message. The iconography of throwing the Pope to the ground and beating him around the head is very common in Protestant Reformation art. Next to the Pope are two friars, identified by their shaven tonsures, looking furtive and attempting to escape, perhaps with the riches of the Church. In the top right hand corner of the painting, we see a bonfire in which religious pictures, removed from parish churches, are being burned to symbolise the removal of the vestiges of Catholicism from English religion. Representations in English art of iconoclasm in action are very rare, although continental Europe offers many examples.

So what does this painting mean? It is an allegory of the success of the Church of England in removing Catholicism from the country. It was painted approximately twenty-three years after the scene depicted here, the death of Henry VIII. It is sending a pro-Protestant message, celebrating the Protestant revival under Elizabeth even though she is not portrayed. Less than a generation previously, Henry's first daughter, Mary, had brought Catholicism back and the situation regarding English religion was much more uncertain than this suggests. On Henry VIII's death, England could not yet be considered

a Protestant country, but the work begun by Edward VI and his sister Elizabeth made that a reality. So, the chronology is important here. The painting tells us more about the religious situation in England in 1570, the approximate date of production of the painting than it does about Henry's death. It also tells us how, by the last quarter of the sixteenth century, the Tudor dynasty wished to be memorialized as great Protestant reformers. The painting is also unusual because it presents its message to the viewer in an incomplete state. We do not know why it is that this painting was never finished, but the blank white spaces were probably intended to contain further words or pictures of anti-Catholic propaganda.

Case Study Two: Dorothea Lange's 'Migrant Mother' photograph, 1936

This is one of a large series of photographs documenting the Great Depression, but this one is by far the best known. To understand why Lange took these images we need to examine Lange's life. She was a second-generation German immigrant whose family settled in Hoboken, New Jersey. Lange's role as a photographer was state sponsored. She worked for the Farm Security Administration, one of the agencies founded during President Franklin Roosevelt's response to the Great Depression. She travelled the country with her second husband, as he interviewed and she photographed. This organization attempted to document and alleviate rural poverty in the US of the 1930s, and it was criticized as being too socialist by some because it collectivized agriculture. The Farm Security Administration had many photographers, including Lange, working to document the problems of rural poverty. Along with literature such as Steinbeck's novel *The Grapes of Wrath*, these images educated many urban Americans, as well as viewers around the world, about the problems suffered during the Depression.

Dorothea Lange made this statement in a magazine article of 1960 about why she took the picture:

I saw and approached the hungry and desperate mother, as if drawn by a magnet. I do not remember how I explained my presence or my camera to her, but I do remember she asked me no questions. I made five exposures, working closer and closer from the same direction. I did not ask her name or her history. She told me her age, that she was thirty-two. She said that they had been living on frozen vegetables from the surrounding fields, and birds that the children killed. She had just sold the tires from her car to buy

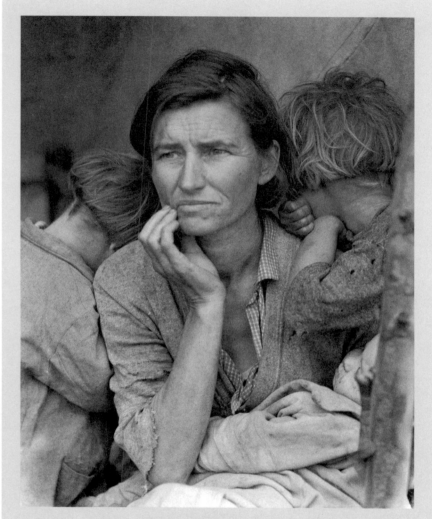

FIGURE 2.5 *'Migrant Mother' photograph by Dorothea Lange, 1936. Public Domain.*

food. There she sat in that lean-to tent with her children huddled around her, and seemed to know that my pictures might help her, and so she helped me. There was a sort of equality about it.[7]

This is really important because her statement addresses the relationship between the subject and the 'author' of the image'. Who is in control? Is the artist passive and merely recording what is there? Or is the author in

control and directing the passive subject? Is the subject rendered passive by the intrusive 'gaze' of Lange's lens? Lange answers this by claiming that her photograph was the result of collaboration between her and the 'migrant mother'. When Dorothea Lang chose to photograph *this* woman (and not a man, for example) she did not realize that she was creating an image that would become the icon of the era. We must ask ourselves why has this image come to summarize the effects of the Great Depression on America's poor and destitute?

In order to further add layers to our understanding of this image, we must give the subject of it a name. She is Florence Owens Thompson, born in Indian Territory, Oklahoma in 1905. She had six children with her first husband before he died of tuberculosis leaving Florence in a perilous position. At the time the photograph was taken, she was travelling around California looking for work. She had stopped in a pea-pickers' labour camp in Nipoma where several thousand other migrant workers lived, who were without work or food because harsh weather had destroyed the crop. Lange's photos, sent to the *San Francisco News* and to the Resettlement Agency, encouraged the government to send food aid to the region, but by the time they had done so, Thompson and her family had moved on. Later, after Lange's death, Thompson said in a local newspaper report that she wished Lange had never taken her photo because she (Thompson) had never got a penny out of it.[8]

This is an example of how historians must move beyond the iconic nature of a particular image, beyond the assertion that an image merely epitomises an era. The story of the artist and her subject are more interesting and the image is merely a snapshot (literally) of a time when the two came together. The specifics of the context and place of their meeting are important, as is the legacy of the effects of the public distribution of the photograph.

Case Study Three: Holocaust photographs

Because photographic equipment was cheap and common in Europe by the time of the Second World War, this medium was used to record some of the horrors of war and the Holocaust. It is vital for historians to understand the purpose behind the production, collection and preservation of these images. They are taken from the Yad Vashem collection. The cataloguing information is thorough and gives historians contextual information to help to answer the key questions. For example, part of the collection is an album known as 'The Auschwitz Album'. This comprises a group of photos taken by Ernst Hofmann and Bernhard Walter, photographers who were members of

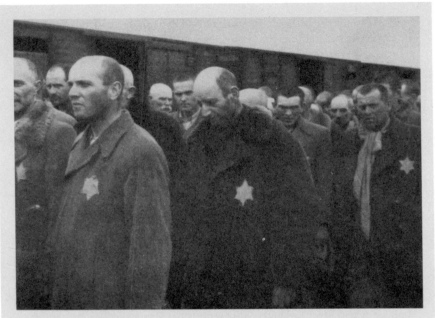

FIGURE 2.6 *Jewish Men standing in Line at Birkenau, 1944, from the Yad Vashem collection (FA268/47). Public Domain.*

the SS (Schutzstaffel – Hitler's 'protection squadron') in Auschwitz-Birkenau during the arrival of a transport of Hungarian Jews in 1944. It is of crucial importance to scholars because it represents the only visual evidence from inside the concentration camp of the processing of the inmates. In fact, the only aspect of camp life not revealed in the collection is that of mass murder itself.

The album was in private hands, belonging to Lily Meier, but was not a hidden archive and it had been used several times as evidence in trials such as the Auschwitz trials in Frankfurt. Scholars have gained access to the resource because the owner donated the photographs to Yad Vashem, the Holocaust remembrance organization, which restored and digitized them. The photographs reproduced here document the arrival process during the second half of 1944 of Hungarian Jews from the Tet Ghetto to Auschwitz-Birkenau extermination camp.

This is an excellent example with which to think about the viewer's immediate reaction: horror, chilling, fear, because suddenly these photographs have made real the most repulsive part of human history: genocide. Our second response is often that of separation. We want to put distance between ourselves and this subject, not wanting to engage on a purely emotional level, but wanting to be objective yet unsure how to respond appropriately

and with respect. I think it is important not to dismiss that first emotional, empathetic reaction. As a historian, your job is to tease out the motivations of people in the past and to convey to readers today the experiences of those in the past. If you do not have a personal response to their lives, it can make the task harder rather than easier. Embrace your emotive response; do not dismiss it. Photographs often produce a more immediate visceral response, because we, like Roland Barthes, perceive an inherent truth behind photos: 'this thing really was here'.

However, as a scholar you need to move on and analyse the source and so you need to probe deeper and ask some significant questions. The Yad Vesham website provides enough information to answer key questions. These images were taken by members of the German authorities. What was their purpose in taking them? It makes us think that in this case the camera was being used as another mode of control and dominance. Now these photos are displayed as part of the memorialization of the Holocaust, the deep desire to never forget the horrors. But originally they were taken to catalogue, to observe or even to spy, to probe vulnerable people at what must have been the worst point of their lives. This change in meaning is really important. We also cannot view these images now without an awareness of what happened at Auschwitz. Perhaps the people in the pictures did not know what was going on, and perhaps even the photographers were not aware of its full extent, but we are aware, and that knowledge contributes to our response to the images. As mentioned earlier, do not suppress this response, but rather acknowledge it and the reasons behind it before bringing a sensitivity and respect to your analysis of the images.

Case Study Four: *Mappa Mundi*

'Mappa Mundi' simply means 'map of the world' in Latin. Currently the most famous *Mappa Mundi* is housed in Hereford Cathedral. Latest research suggests that it was produced in around 1300. The map is drawn on a piece of calf skin, also known as vellum, and is well over 150cm tall. The map was probably produced by a map maker named Richard de Battayle or de Bello (according to John Ashton, a Victorian editor of *John Mandeville's Travels*), who held a prebendal stall (a senior cathedral position) based first at Lincoln and then Hereford. The most interesting aspect of Mappae Mundi is that they are not like modern maps. We assume that the aim of a map is to summarize geographical knowledge of the period of its creation in as realistic and accurate manner possible, using devices like scale and compass to render its realism understandable to the audience. However, Mappae Mundi do not do

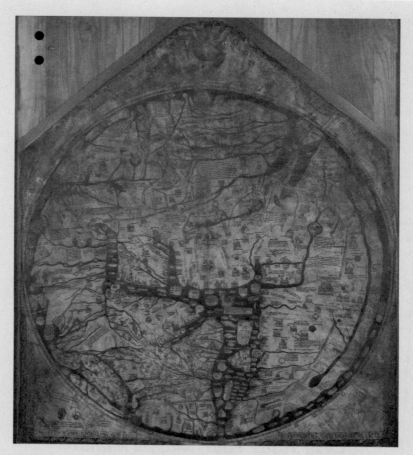

FIGURE 2.7 *Mappa Mundi (Hereford Cathedral). Copyright of the Hereford Mappa Mundi Trust and the Dean and Chapter of Hereford Cathedral.*

this. They depict countries, and like early modern maps, animals and wildlife, but also biblical events. Mappae Mundi are religious artefacts as much as geo-political ones. They are part of a genre of medieval mapmaking known as the T-O maps, also known as the Beatus map, named after the eighth century creator of the first T-O map. The 'T' represents the seas and rivers dividing the three known continents and the 'O' the ocean surrounding them. This genre of map was popular until the Renaissance when Columbus and Vasco da Gama and others changed the understanding of the world through their voyages.

The central focus of any map is crucial because this helps us to understand the intentions of the map maker. In Hereford's *Mappa Mundi*, Jerusalem is at the centre, again reiterating the spiritual significance of the document. It

also depicts fifteen religious events or places including the Garden of Eden ('paradise') and the final resting place of Noah's ark. But the map should not be read as an exclusively Christian document, because it also contains eight drawings that reference classical Greek mythology such as the Golden Fleece, the Minotaur and the Pillars of Hercules. In fact the map is not interested in reflecting the latest knowledge of the 1300s, so does not reflect the modern concept of a map but instead is a spiritual description of the world.

This is of interest to historians because the *Mappa Mundi* is illustrative of the changing way that people in the past conceived of their surroundings as well as the changing meaning of maps. In the medieval period the natural world was not considered divorced from the spiritual realm and this can be a real challenge to grasp for twenty-first century students brought up in a mostly secular world. While we know little of the map-maker's beliefs and attitudes beyond his name and occupation, by comparing this map to others in the same genre we can begin to understand how Mappae Mundi contributed to the medieval understanding of the world. The troubled history of such documents that had to be kept hidden during times of iconoclasm such as Cromwell's Interregnum also shows how the significance of this document has changed over time. The issue of audience must also be addressed. This map was not designed to be a public document, but was kept in the library or elsewhere in the cloisters of Hereford Cathedral for the use of the bishops, prebendaries and other ecclesiastical staff. The manufacture and use of these maps was a spiritual as well as a secular act: to provide inspiration as well as information.

Case Study Five: Herblock cartoons

As shown earlier, cartoons are an excellent way to gain access to the political attitudes of the population, but they must be used with care. An example is the Herblock cartoon collection from the United States of the McCarthy-era. During the 1950s, an era of increasing prosperity and international paranoia, a 'Red Scare' triggered by the activities of Senator Joseph McCarthy targeted actors, producers and directors in Hollywood, public sector workers across America and those in political office locally and in Washington. The cartoonist, Herb Block, was working from 1929 to the year 2000 (he died in 2001 aged 91). He won Pulitzer prizes for his work and became one of America's most renowned political commentators. Block was credited with inventing the term 'McCarthyism' to refer to the Red Scare era, so he made history as well as commentating upon it. He was angry that President

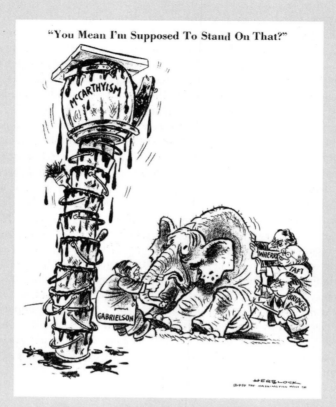

FIGURE 2.8 *'You Mean I'm Supposed To Stand On That?'*
Published 29 March 1950. A 1950 Herblock cartoon.
© The Herb Block Foundation.

Eisenhower didn't do enough to prevent the excesses of the McCarthy era and so he felt that it was important to give a voice to those who disagreed with McCarthy.

As well as the huge popular audience that Herblock's cartoons gained across the country, they also influenced those in power too. During the Army hearings (meetings in the United States Senate during the Red Scare), journalist Walter Winchell told Phil Graham, the publisher of *Post* magazine, that he had come upon Senator McCarthy shaving at midday and complaining that he had to shave twice a day on account of that guy (Herb Block) and his cartoons. Apparently his caricatures of the senator as an unshaven, belligerent Neanderthal in a suit found their mark.

Herblock himself thought reflectively about the significance of cartooning. He wrote: 'so what I'm talking about here is the cartoon as an opinion medium.

The political cartoon is not a news story and not an oil portrait. It's essentially a means for poking fun, for puncturing pomposity. Cartooning is an irreverent form of expression, and one particularly suited to scoffing at the high and the mighty. If the prime role of a free press is to serve as critic of government, cartooning is often the cutting edge of that criticism.'

Historians must consider the intention of the creator of the cartoon, as well as examining the distribution of the newspaper or magazine in which it was published. The political bias of the publication is also crucial (i.e. whether the newspaper had a strongly right-wing or liberal or left-wing editorial). Cartoons should always make us consider whose attitude is being reflected. Is it as Herblock suggests 'the ordinary people', often without much of a voice in the political process? Or are the ordinary people being told what to think by the cartoons that make them laugh over their breakfast as they read the paper?

Case Study Six: Tattoos, graffiti – images on medium other than vellum, parchment or paper

It is important to remember that the visual image can appear anywhere in our world and not only in art galleries and in archives. The historical significance of images away from paper or vellum is vast. Many historians spend so much time focusing on the image and its manufacture and meaning that they forget to consider the medium. Such media as tattoos and graffiti have an important place in contemporary culture but also have a long heritage too. They can tell us something about the class, identity and race of the artist and, in the case of tattoos, the 'wearer'. Both genres also have a connection to the law and criminality, with, until very recently, tattoos being associated with criminal classes and graffiti artists also treading a fine line between art and criminality as they either enhance or deface the built environment around them. In both cases, the choice of a particular image has great resonance and also the illustration can be textual (i.e. words written in striking fonts or colours). The choice of font for both of these art forms denotes identity and values. Exploring the history of these mediums can help us to realize how blurred the lines are between the visual and the textual.

For example, by examining tattooing in seafaring and criminal cultures, we can see that the tattoo has more significance for the 'wearer' of the tattoo than it does the artist. In many historical cases, tattooers are anonymous, but the symbolic meaning of their art can be derived. Tattoos tend to signify a rite of passage, the passing of a particular milestone such as being at sea for

a certain amount of miles. Similarly, in criminal gangs, having committed a particular crime that allows induction into the organization can be symbolized by tattoos. They signify something very personal and yet at the same time, connote belonging to a select group. Tattooing is not historically static, and its meaning and adoption has changed considerably considering that it has been practised since the Neolithic era and is common across the globe in a range of different societies.

Graffiti similarly has a shared language and symbolism, with artists remaining largely anonymous until the late twentieth century. In recent decades it has become an art form with graffiti art proudly adorning our towns and cities and art galleries, but prior to that, graffiti had a different meaning. Through boredom or vandalism, graffiti has also existed since ancient times and its cultural meaning usually related to ideas of inscribing possession, authority or rebellion. For example, graffiti depicting pre-Christian pagan symbols found in medieval English churches can be read as acts of rebellion. But we can also interpret that they reveal the syncretic nature of rural religious practice at that time. Perhaps the artists were simply bored during the interminable Catholic mass to which they contributed very little. At the very least, the existence of such graffiti reveals the essential human desire to inscribe their presence visually and permanently in the environment.

In the case of both of these genres, writing is often used almost as an image. By this I don't mean that the meaning of the words written is unimportant. But also that the form in which they are written, the chosen font for example, is crucial. Tattoos often share a particular writing style (gothic lettering being popular at the very end of the twentieth century), influenced by other forms of writing such as the titles on album covers. Late twentieth-century graffiti also has its own well-used letter forms, but in a historic context, graffiti of words can reflect the influence of particular fonts in use at the time. These might be in imitation of the format of manuscript or printed books, or even of other written monuments such as gravestones.

CHAPTER THREE

Film, TV and Audio Sources

Aim: In this chapter, we will explore how historians can make use of four types of sources: feature film and documentary film, television programmes, audio recordings such as radio broadcasts or music and finally recordings of oral history. First, we will look at the theoretical underpinnings of historians' approach to these sources, developing from the discussion in Chapter One of what film studies might usefully teach us. Second, we will look at the technical aspects of the discipline that we need to grasp and also investigate how to access past audience responses to these media. Finally, we will think about the ways that historians can build on this knowledge and use film, TV and audio sources to illustrate their own arguments. In a concluding section, we present some case studies of particular sources that serve as an example on which to base your own research.

As we saw with photography in Chapter Two, it is important to remember that film is not an exact representation of things that happened in the past, despite our assumptions that this is the case. A history student will view a film in a different way from either a film studies student or a member of the public watching that film for leisure purposes. We have to acknowledge that the meaning of the film also changes over time as the nature of the audience changes. We must interpret a film in much the same way as we would attempt to interpret a still image or a text-based source. As Janet Staiger has eloquently argued, the moving image is a *document* and not a *monument* of the past.[1]

As this chapter will show, it is the nature of film as a mass media that is crucial to understanding its significance. It is only doing half the job

to appreciate a film as a work of art. We need to understand its viewers' perceptions. Film emerged at a time in the late nineteenth and early twentieth centuries during which time technological developments were opening up a range of media to ordinary people whose access was previously limited. Literacy had increased from the mid-nineteenth century onwards and the costs of print culture had reduced, making it more accessible. However, from their inception, the media of radio and film were accessible to ordinary people, making the cultural awareness of this class available to historians. Since the year 1900, mass media and its prevalence had not escaped criticism but despite this, films, radio, propaganda and later television all became huge cultural influences.

Interpreting feature film

How should historians approach the feature film in order to use it analytically and meaningfully? As always, the first task with a primary source is to define it successfully and accurately by recording first its content, second its production values and circumstances and finally its reception, by contemporaries and later generations. It is not always easy to determine these aspects with films and it certainly is not possible to derive them simply from viewing the film. As with the assessment of still images, analysis of film needs to be accompanied by archival work, looking for what Thomas Cripps calls 'the scaffolding' that surrounds a film.[2] This scaffolding helps the scholar to interpret the meaning of the film and involves examining supplementary documents such as interviews with stars and directors, descriptions of the production process produced by the studios, magazine reviews once the film is released and newspaper articles discussing any controversy surrounding the film, such as the 1915 debates over the racially provocative silent film *Birth of a Nation*.

We must also theorize the meaning of the piece, and this is where film studies can help us. The late Robert Sklar has offered us a three-part paradigm with which to interpret feature films. This paradigm shows chronological change: as a scholar you can see how the methodology of approaches to film has changed even when the film remains fixed in celluloid. The first paradigm is the 'psychological'. Emerging at the end of the Second World War, based on the work of German film critic, Siegfried Kracauer, this was the idea that films somehow reflect the mentality of a nation, not necessarily their conscious feelings but rather their psychological disposition at a subconscious level. This approach suggests that we as historians can use film to look for the values of the time in which they were produced, but that these values will not always be obviously positioned. Kracauer's later work included an examination of Nazi propaganda films but his argument on the psychological importance of film was derived from an assessment of German cinema of the 1920s.

He traced the visual and narrative tropes that he claimed reflected a desire for order.[3] This idea argues that there is a single dominant ideology of a film and that this will tell us about the society that produced it. Of course it is vital to consider the genre of the film too, as well as who its intended audience was, but the basic understanding of Kracauer was that the significance of the film was revealed within the film itself. The second paradigm emerged in the 1950s and 1960s, and that was the 'aesthetic' approach. We have already examined this in Chapter One in relation to the importance of the 'auteur'. This approach prioritizes the style and theme chosen by a single artist, in this case the director.

The final paradigm emerged in the late sixties and into the 1970s and is called by Sklar the 'Ideological/Cultural' paradigm. This reflects the Marxist influence of post-structuralist thinkers such as Althusser and Lacan. They argue that it is through discourse that an individual subject is able to understand the world and themselves. Therefore, according to these theorists, the most important aspects of a film are the subtle ways that a film conveys its meaning. 'Discourse' does not simply mean the spoken language of the film, the dialogue, although that is included. It also refers to the 'language' of the film itself, that is, the ways in which the film is constructed to convey meanings, to influence the audience. You could interpret this to cover every aspect of what the audience sees and hears on screen, apart from the story itself. This immersion in the content of the film was challenged by thinkers such as E. P. Thompson and Raymond Williams, who prefer to see films through a 'culturalist' lens. This means that they are almost moving back full circle to the work of Kracauer, arguing that the film must be placed in a broader context of the culture of the particular time and place that created it. Whereas Kracauer argued that a film reflected the subconscious world of a nation, Thompson and Williams suggest that a film can only be understood by exploring the conscious cultural output of that nation and, in line with their Marxist heritage, they believe that it is essential to study the political and economic structures of the society and industry that created the artefact.

Creation of a film

To understand the practicalities of the ways in which a film was created is important for a historian because the choices made by the creators of film and the chronological development of the technology that they have at their disposal, affect the meaning of the artefact. This aspect of film interpretation illuminates a problem that affects all students of film. We are so familiar with the medium that we assume that we can approach it sensitively and in an analytical fashion, but in reality very few scholars stop to consider the precise means by which a film is created. Three aspects of science and technology come together in order to create a piece of film: the

ability of the human eye to allow vision, the technology of the photograph, and the development of the moving picture camera.

The components of a film must be understood piece by piece too. Watching an entire three hour movie and analysing its meaning can seem daunting, especially when considering that thousands of words have been written about single shots in some films. The technical language of film production allows a history student to contextualize their understanding of how to interpret that film, whether it is through the analysis of a single shot, a group of shots known as a scene, an entire sequence, or the film as a whole. Visually, each shot contains two basic elements: the photographic elements such as the duration of the shot, its lighting, the colour used, and also the *mise en scène*, referring to all the other elements that go towards constructing a shot, so, for example, aspects such as the scenery and the costume. Added to this are the audio parts of the film, not only the spoken word but also incidental music and sound effects that combine to create atmosphere and move the audience in some way. Thus, historians learn that the visual and audio elements of a shot, scene, sequence and film are as important as the dialogue itself in conveying meaning. The script can be read in isolation from watching the film, but until you actually see the film, bringing together the visual elements too, it is impossible to truly understand the meaning of the piece. Historians also have to be aware of the significance of the editing process in the creation of film. Much of what is filmed ends up on the 'cutting room floor' with the director creating meaning through his or her selection and combination of particular shots.[4]

Audience response

However, as we saw with the interpretation of still images in Chapter Two, historians are less interested in the intricacies of how meaning is produced in a particular medium than in the impact that this artefact had on the culture and society that produced it. Film is important precisely because it is a mass medium and, at least since the 1920s, it has become part of the everyday lives of millions of people across the world. Theoretical approaches to the reception of film by viewers have attempted to explain the impact that such artefacts have on their audience. Each viewer brings his or her own context to the viewing of the film. The viewer's education, family background, peer group, life experience and political outlook all cause them to understand a particular film in a unique way. A viewer's experience with similar films is also crucial here, known as an inter-textual response. Basically, if a viewer has seen something in a similar genre, or by the same director or with the same actor, this will affect his or her viewing of this particular film. A combination of conscious and subconscious responses to the film enables the viewer to create meaning.

In this theoretical model of reception theory, there is no intrinsic true meaning of a film; all film is interpretation by the individual.

There are also theories of collective audience response and these can be used to filter through the minefield of the evidence of what audiences in the past have thought about the film being studied. This theory is known as reception theory or reception analysis. It developed out of critical analyses of responses to literature and is now applied to understand the audience response to other types of media. A famous proponent of this theory is Stuart Hall who has examined the audience response to television. He sees the process of cultural production and reception as one of 'encoding' and 'decoding'. Producers of film and television 'encode' the movie or programme with the messages that they wish to disseminate. Then when the viewer comes to the movie or programme, they 'decode' the messages that are transmitted to them. However, Hall suggests that viewers are not merely passive recipients of the given message when they watch television but rather that their backgrounds allow them to respond in one of three ways: dominant/hegemonic, negotiated or oppositional. The dominant or hegemonic response suggests that viewers decode the message exactly as was intended by the creator of the cultural artefact. Negotiated viewing accepts some aspects of the message but rejects others, whereas oppositional viewing means that the individual has rejected the 'code' of the artefact and instead imposes his or her own interpretation on it. Hall also says that collective response is possible; each individual is not isolated in his or her response to the medium. Such a collective response can change the entire meaning of an artefact or a particular genre. Cultural theorists, such as Dick Hebdige, have developed Hall's theory to show how sub-cultures, such as punk, move from an oppositional to a dominant position within culture.

Historians must inform themselves of this theoretical underpinning. However, their mission is to find evidence of audience response to a particular film in a particular chronological era. Cultural theory might help us to interpret responses to culture, but we also need to historically situate them too. To do this we need to go back to the earliest days of film and trace the way that audiences responded to it. Theorists like Hall assume a familiarity with the medium that in the twenty-first century has an almost global reach. However, only a century ago film was capable of shocking audiences – of profoundly challenging their sense of self and their perception of what was physically possible. As Jeffrey Richards has explained, early documentary films profoundly moved their audiences because it appeared as though people had been 'reanimated'.[5] Audiences quickly adjusted to it and early pioneers marketed it as a new, objective medium. As with photography, audiences have always struggled to deal with the contradictory ideas of the medium. We believe that film depicts what really happened, but we also know that its creators can manipulate reality. Historians of early documentary film record that as with photography, the medium was

being moulded and adapted from the very earliest examples, for example, through using recreations or selective editing.

It is possible to access specific audience reactions by exploring documents that accompany the release of a film. Reviews in newspapers and magazines published at the time of the film's release are an excellent source of information. However, the scholar must ask 'whose response is this?' The individual who wrote the review will have his or her own particular context. Can we say that his or her ideas and interpretations are typical of their time, of their race or class? Some reviews are written with the aim of encouraging people to watch the film for leisure or for educational purposes, while others want to discourage audiences from attending; still others are written to entertain and show the wit of the reviewer. Letters to newspapers and fan magazines are another way of accessing the thoughts of an individual viewer. It must also be remembered in both of these cases that the publication in which these thoughts appear has its own agenda too. Why has an editor chosen to publish a particular letter and not another?

Statistical evidence is another way of gauging the response to a film. Examining the numbers of people who watched a particular movie at the cinema, or the sum of money it made at the box office, perhaps compared to other similar films or to the numbers watching particular TV programmes, allows the historian a way to judge the contemporary response to a film. However, these statistics do not tell us the nature of the response. A film with high audience figures may have achieved those because it was very controversial and people wanted to see what all the fuss was about. Audiences may have strongly disliked what they saw but still paid to see it in large numbers anyway. An invaluable resource for historians interested in cinema-going from the late 1930s until the 1960s is the mass observation surveys. These surveys were undertaken in the UK by unpaid volunteers and were designed to report on various aspects of society. One of the most interesting aspects was the reports on the response to newsreel footage during war time. This archive is held at the University of Sussex, but much of it is now available online.[6]

Other responses to film can give us a sense of the changing values of a particular era. Censorship is one way to access these responses. The censorship of Hollywood films, particularly with regard to attitudes towards sex, violence, homosexuality, marriage and bad language, has ebbed and flowed throughout the twentieth century and raises interesting questions about whether governmental or industrial control restrict artistic freedom, over-protects audience or reflects the social mores of the time. An example of how censorship functions is one of the most powerful censorship regimes, the Hays Code, in force from 1934 until 1968, when the internationally recognized age rating system was adopted. The Hays Code was written in 1930, by a Catholic layman and a Jesuit priest, in response to a public desire (driven by religious, especially Catholic,

campaigning organisations) to clean up Hollywood. A series of scandals involving criminal activity by its stars had triggered this, as well as a fear that some films glamourized the delinquent lifestyle of the depression-era gangsters. Behind the nervousness of religious groups was the idea that watching films that did not moralize about violence or sexually illicit behaviour would encourage impressionable young people and the ignorant poor to adopt such behaviours themselves. The Hays Code, named after Will Hays, the president of the Motion Picture Producers and Directors of America organization, was finally accepted by all studios in 1934 in response to threats of cinema boycotts by Catholic organizations. The code's purpose was to prevent audience sympathy resting with anyone undertaking immoral behaviour. The law, the flag and religion must not be ridiculed but the Code also protected audiences from being exposed to depictions of nudity, drug use, criminal activity, homosexuality, sexually transmitted diseases and childbirth. Adultery was censored but so too was sexual display between married couples and even 'excessive and lustful kissing' was outlawed. The code had a racial element too; it forbade the depiction of 'miscegenation'.* The Code was only gradually abandoned from the late 1950s onwards because of the influence of television and foreign films, which were not subject to such rigorous censorship. Its long-term success was not due to pressure from the government or from law enforcement but rather because studios preferred to enforce their own code rather than submit to external federal censorship.

Television

So far, we have been discussing the feature film. Let us now consider the medium of television. It gradually increased in cultural importance from the late 1940s onwards until it became ubiquitous in almost every household by the 1960s. Television programmes can be studied alongside films because their technology is similar and the theory behind their construction and reception is also similar. However, television has a different social meaning in that it was always intimate and domestic. This meant that the public's reaction to television was often more intense. You did not have to leave the home to purchase a television programme as you did with a movie. In the early days of television watching, viewing a particular programme was often a communal activity as friends and neighbours shared the experience by watching the 'set' belonging to the family that had one. But by the late 1950s, when sets were much more common, television watching became something done privately in one's

* Definition: 'miscegenation' is racial mixing, in this case, the depiction of such inter-racial sexual relationships on screen.

own home. Meal times, leisure activities and consumption of other goods were all strongly influenced by the presence of the television in the home.

Although so far this chapter has focussed on film, documentary and television, a similar resource for history students must surely be the theatre. By examining the history of theatre performances rather than the play texts themselves, historians have another avenue to explore the changing significance of visual spectacle. Again, as with film, the play itself can be a topic of study or a primary source through which we analyse the past. The changing political and class ramifications of the theatre as it morphs from a lower-class activity to one considered to be 'high culture' show that the meaning of a particular medium is not static over time. The establishment of institutions called 'theatres' during the early modern period are another new development, showing the professionalization of the industry and a move away from the street theatre of pageants, mummers and mystery plays.

Audio

Let us turn to audio recordings. These usually take one of three forms: radio broadcasts, which can be documentary or fictional; recorded music; or recordings of key events such as speeches. Historians often pay little attention to music but this is a shame because it provides an important type of documentary evidence of our past. It is possible to study a genre of music, a particular piece or a particular recording or performance of that piece. Songs are made up of a combination of the musical notes and the lyrics. As with plays and films, the lyrics of a song can be studied independently, but to truly understand the impact of a song, its rhythm, instrumental music and performance must be examined. Historians must also be aware of the reasons why a piece of music has been recorded. Is it because it was considered historically significant, epitomizing a particular composer's *oeuvre*, or part of the output of a star performer. Is it released to make money? To entertain? To preserve it for posterity? Does it have a long life as a piece of oral history shared and adapted prior to being recorded, or, as with pop music today, was it written to be released commercially and did any cultural sharing take place after the event? Music also plays a significant role for non-literate societies and groups in that it preserves history, heritage and identity. It becomes a means of remembering as those who can sing particular songs are valued as the holders of historical knowledge in the community and they teach others the lyrics of a song as a way of teaching them about their own community's past.

The work and religious songs of American slaves are a very interesting example of these conundrums. No recordings exist from the period prior to the ending of slavery in the United States, so all recordings are

historical accounts themselves, the recollections of people remembering the songs that they or their older relatives used to sing under the system of slavery. Many of these were recorded in the early years of the twentieth century when folklorists such as John Avery Lomax, along with his son Alan, travelled the Deep South aiming to preserve the musical heritage of African-Americans by recording their memories of the songs they sang in their childhood. Does this purpose affect their content? Is it possible to record a definitive version? Has memory changed the song over time? Lomax began his career by recording cowboys' songs in his native Texas, but during the Depression era he was given state funding to collect the songs belonging to the folk traditions of many marginalized groups in the south, such as prisoners and poor sharecroppers. He always had state-of-the-art equipment, such as a brand new phonograph and was the first to record many blues artists such as, in the summer of 1933, guitarist Huddie Ledbetter, better known as Leadbelly, whom he met in Angola State Penitentiary, Louisiana. Lomax had a long relationship with Leadbelly, employing him as a driver and engaging him to perform as an oral illustration of Lomax's lectures. Lomax also tried to establish him as a commercial recording artist when he was released from prison.

So, music should be studied in its own right as a cultural artefact but also in relation to key historical events. The interaction between such historical developments as the civil rights struggle and its accompanying music is a complicated one, with music both depicting and constructing change. The freedom songs conjured up the era and allow later audiences to access the feel of the time, but more than that, they actually contributed to change. They were sung in a range of settings, such as on marches and in prisons, and often depicted the moral urgency of the cause, such as in the case of the song 'We Shall Overcome'. It had gospel origins and had also been used as a protest song in a union dispute in South Carolina in 1945 but was popularized by folk singer Pete Seeger in the early 1960s. By then it had already acquired a connection with the civil rights movement and this was cemented when in 1963, Joan Baez led a crowd of 300,000 people singing it during the March on Washington for Jobs and Freedom. Later in the 1960s, Martin Luther King and Lyndon Johnson repeated the phrase 'We Shall Overcome' in their speeches. The song had an important afterlife and in the later twentieth century was used by protesters in India, Northern Ireland and Czechoslovakia.

Documentaries

Radio, television and film share a common challenge for the historian in that it can be difficult to differentiate between 'actuality footage', that is recordings of events that actually took place, and dramatized action presented in a studio by actors. Many genres of historical documentary

employ both to such a degree that it is difficult even for experienced watchers or listeners to distinguish between the two. A classic example of such a misunderstanding by an audience took place in 1938 in the United States when the fictional drama by H. G. Wells, *The War of the Worlds*, starring Orson Welles, was aired. The first part of the drama consisted of a series of mock radio news broadcasts. The effect was magnified because the drama ran on a channel that did not break up the show with commercial advertising. Although a warning was broadcast at the start of the show, some listeners who tuned in late genuinely believed that they were listening to news broadcasts warning of an impending alien attack and they called the police or the radio studio in alarm. The fictional simulation of the factual news medium had been so accurate that listeners found it impossible to distinguish between fact and fiction. The anxiety was exacerbated by the broadcast coinciding with the militarization of Germany. National newspapers made much of the so-called panic, but sociological research afterwards remained divided on the impact of the broadcast and suggested that this newspaper coverage actually blew the panic out of proportion. Even though it is impossible to quantify how many in the audience considered the broadcast factual, it illustrates how easily it is rendered possible blur the lines between fiction and reality.

Another example, again playing on the audience's familiarity with the factual news genre as well as to entertain, is in the Italian film *The Battle of Algiers*. It is a 1966 war film depicting a battle in the Algerian war, shot in newsreel-style black and white footage. It was so convincing that US audiences had to be reassured by a disclaimer that this was not a documentary. The film had an interesting impact on movements of the late 1960s such as the Black Panthers who took the urban warfare and guerrilla tactics depicted within the film as inspiration for their own struggle. More recently, in 2003, the film was screened at The Pentagon because the US Department of Defence thought it offered lessons on how to behave towards civilians during the Iraq conflict.

One of the most influential television series of all time was the 1970s series *Roots*, based on Alex Haley's novel of the same name. It has been estimated that 85 per cent of US households watched some or all of the series. It courted controversy because Haley claimed that the series was based on genealogical research and that the family depicted was his. This proved not to be the case and Henry Louis Gates later acknowledged that much the work was of the 'imagination' and not 'historical scholarship'.[7] Thus, when examining the reception history of *Roots* we learn as much about the United States of the 1970s as about its slave past. This reveals a tendency in documentary films as well as movies to depict history through the lens of hero creation. Directors and writers often want a simplistic narrative structure that leads the audience to latch on to one heroic character, in the case of *Roots*, the Gambian-born slave Kunte Kinte. As historians, we know that the historical past is not that clear-cut. The line between fiction and

reality has been blurred more recently with the 'found footage' genre in which low budget horror movies such as the 1999 film *Blair Witch Project* purport to be documentary films taken on hand-held cameras.

I am not arguing that documentary film or radio programmes are somehow voices of the truth while fictional programmes are not to be trusted. Of course factual broadcasts are still manipulated too and they are trying to encourage a particular outlook in their audience. Documentaries can be used to issue a plea for more attention to be given to a particular topic, and so the historian can ask whether this indicates that the topic was of concern to the people in the audience. The way that footage is edited and presented can intensify the audience's understanding of the topic, but the line between that and distortion is narrow.

Television and radio news and film newsreel must also be treated with suspicion. Historians must be alert to the use of particular reporting techniques such as the expert interview and the eyewitness on the scene, both methods that are used frequently to add authority and gravitas to the reporting. We must ask who is manipulating the message and the agenda in television news and how? The editors are very influential because of their role in determining the order in which they present and connect stories to commercial advertisements. The values of journalism as a profession are to uncover stories and to reveal the truth: so is their role in contention with that of television companies who want to increase audiences and revenue? Reporters like to see themselves as agenda setters rather than simply reacting to events or giving the public what they want. Do journalists and editors tell us what is 'news', what is happening in the world and what is most important in the events of our world? If so, are our attitudes to current affairs manipulated by news broadcasters? This challenges the assumption that news broadcasts simply present 'the facts' to us and that we can determine what is significant. If this is true, what role does public opinion have to play? In the twenty-first century we increasingly see news broadcasts interrupted to discuss viewers' responses via social media. 'Citizen journalism' is encouraged as members of the public untrained and unpaid are able to 'break' stories. Is it possible that those responses were as important in earlier news reporting? A comparison to the way that stories are broadcast in print media is very apt here. The selection and prioritization of stories in any medium is governed by 'news values', a set of criteria that rank stories and determine how they are depicted. There are many different lists of such values, but one list compiled in 1973 by Galtung and Ruge lists twelve factors that determine whether a story will receive coverage.

1 Frequency: if it is sudden (long term trends receive less attention).
2 Threshold: size of an event determines its importance.
3 Unambiguity: story must be accessible to the public, if not it should be possible for the media to simplify it.

4 Meaningfulness: does it have 'cultural proximity? Does it affect our home culture?

5 Consonance: does it contain familiar thought patterns appeal to viewers?

6 Unexpectedness: if a story has a surprise element it is more newsworthy.

7 Continuity: once a story achieves importance, it should be seen through to its conclusion.

8 Composition: balance of good and bad news, foreign and domestic.

9 Reference to elite nations: developed world more likely to be covered, developing only if 'meaningfulness' criteria applies.

10 Reference to elite people: stories covering the famous are more attractive than those covering ordinary people.

11 Personalization: story tells about the role of individuals rather than structures or systems.

12 Negativity: bad news stories are more attractive to broadcasters.

These news values illustrate that the selection of stories is not value-neutral. Regular news broadcasts began in the 1920s on the medium of radio. Then, since the early 1940s, television news imitated that format, with fifteen-minute bulletins becoming a regular feature of broadcasts. Even then, immediacy was considered very important. In 1941 when the naval base at Pearl Harbor in Hawaii was bombed, because it took place on a Sunday when no bulletins were scheduled, programmes were interrupted for a special news broadcast. However, the significance of television news broadcasting as a potential propaganda tool had not yet fully been appreciated and the technology was in its infancy, shown by the way that the BBC suspended television broadcasting throughout the Second World War in order to save money and prevent the transmitter from acting as a guide to enemy aircraft. The shutdown took place on 1 September 1939, and the final programme broadcast for nearly seven years was a Disney Mickey Mouse cartoon! Therefore news-reels, radio and television news broadcasts are a wonderful resource for historians as long as they remember that it is the way of representing the news is the main focus. Such broadcasts should not simply be a tool to uncritically learn about the events themselves.

Oral traditions and oral history

There is a particular historical method devoted to the recording of people's memories and histories using the oral medium. This has two separate and distinct functions: firstly to try to access the past of oral (i.e. non-literate) societies, and secondly, to try to record the memories and life histories of subjects who are usually literate, by undertaking oral interviews. These interviews are then used as historical evidence.

In non-literate societies, the function of oral accounts of history is to preserve memory, to create a genealogy and to develop identity. Performance is also very important in preserving history in the oral tradition, so that each time a ballad, for example, is presented to the community, its meaning is slightly changed. It is not possible to fix the meaning of orality, just as it is not possible to fix the meaning of a song that has been sung in many different venues and contexts, despite attempts to record it or write down its lyrics. A single performance may seem transitory but the memories it creates and records are far from transitory.

More sinister motives can come into play, such as those in authority attempting to maintain control. The individuals, groups or parts of society who control the oral tradition have a powerful voice. It is vital for the historian to understand the institutional or private context of the creation of the stories of the history of the group. Understanding certain traditions as 'official' and others as 'private' can be a false dichotomy: instead, neither should be discredited.[8]

When historians collect any sort of oral information, the crucial question is 'whose story is being told?' Of course in many oral history interviews, the subject recounts their own personal experience, their life history with details of their own emotions and behaviours. However, this is not always the case. Sometimes they discuss a generic experience. Perhaps they are consciously borrowing from other stories that they have heard about the past and melding it into their own. Or they may be simply reporting hearsay, unsure of the answer to the question posed but not wanting to appear ignorant. So, a composite life history might emerge involving the lives of family, friends and the community. Even if the narrative is a personal one, a pertinent question is why this particular person has been chosen as an interviewee. Should subjects be selected because they are typical of their gender, class, location and occupation? In this way, does the subject come to speak for many others? Or, might those interviewing have chosen the unusual subject, the one who stands out? These questions indicate why it is important to understand the methodology of those conducting the interviews.

In order to be able to accurately interpret and collect oral testimony, it is important that you understand how these interviews function. Who is in control of the interview? This might initially seem an unimportant question. Let us explore why it matters. Oral testimony as a methodology for historians is predicated in the rise of social history during the 1960s and specifically the increasing importance of the concept of history from below. While some oral history interviews might be conducted with the famous and powerful in society, most are undertaken with what we might call 'ordinary' people. This means that the method of collecting oral testimony has a political function too: to give a voice to the hitherto voiceless. Corinna Peniston-Bird has referred to this methodology as 'recovery history', it is an attempt to go back and preserve the memories of the voiceless.[9] Thus, oral

interviews have to be conducted very sensitively. These subjects often are not used to being asked for their opinions and are rarely given the opportunity to recount their life stories. The very process of selecting an interviewee as representative of a group or as a unique individual confers on them an authority and status to which they are not accustomed. They might use the interview as self-fashioning, to create a new authority for themselves in their community. This must be borne in mind when considering the testimony given and the questions asked. Who is the expert in an oral history situation? Is it the professional, the interviewer? Or is it the subject who, in fact, is the bearer of the knowledge?

The collection of oral history testimony gives the scholar a certain level of power too and this must be acknowledged as a struggle for authority might ensue, resulting in a tense and failed interview. In many instances, historians simply have to work with the type of source evidence that has survived. They are dependent on collectors of material, in libraries, archives or private collections, that have chosen to preserve these resources and now allow public access. Where there is a gap in the archive, a question that remains unanswered, the historian is powerless to change the situation unless a new archive is discovered. However, when conducting oral history interviews, the historian is in a position of much greater strength. They can observe that there is little knowledge about event X or behaviour Y and they can intervene and specifically frame questions that solicit information about this. They are complicit in the creation of primary source material.[10] So it is one of the few times in his or her career that a historian can be in full control of the material to be studied. But with the interviewee also in a position of power, the sharing of information can be contested.

So as a history student with access to oral history interviews, hoping to use them as primary source evidence, what are some of the key problems to be aware of? A major theoretical issue is the role of memory. This is seen as a particular problem with oral testimony but also could emerge if you are using published memoirs. When interviewing a person about their memories of the distant past, it is important to bear in mind the distorting aspect of memory. They might be repeating a story that they have heard, one that happened to a family member or neighbour and passing it off as their own. They may also be harnessing 'collective memory' on a larger scale and repeating the tales that a community, ethnic group or nation tells about itself. These memories can be enhanced or distorted by the media. For example, someone's description of their experience of London in the Second World War might be consciously or subconsciously changed because of the subsequent interest in this aspect of history. The interviewee might assume that a story of war-time London would not be complete without a description of an air raid and a night in the shelter, even if they personally cannot remember such an occurrence. This can lead to the subject's recreation of 'stock characters' from the past too, giving

stereotypical accounts, partly to protect the reputations and identities of people in the past, including themselves, but also because their recall of the event might not be precise and is being embellished by the role of collective memory. An example is the presence of the 'spiv', the petty criminal dealing in off-coupon goods in historical accounts of the Second World War. In recent years there has been a tendency to portray him in a more favourable 'cheeky chappy' light, influenced by comedic depictions such as Walker in the TV series *Dad's Army* (1968–1977) and George Cole as Flash Harry in the *St. Trinian's* films (1954–1966). This could affect a subject's descriptions, whereas contemporary accounts, including so-called spiv-cycle films produced in the years immediately following the war, such as *Waterloo Road* (1945), often depicted 'spivs' harshly as greedy criminals in gritty noir-influenced films, despite their performing a public service.

But even when this stereotyping is not happening, memory can affect our recall of past events. This does not simply mean that a key point has been forgotten and ignored. Remembering can also have the effect of increasing the significance of particular periods and events and distorting them that way. Another concern is that many people's memories do not work in a chronological, formal fashion. It is difficult for those non-historians to put their memories of the past into date order. The interviewee story might be snap shots of feelings and emotions and snippets of narrative with no chronological guide. Estimates made by the subject about particular years or even decades might be erroneous.

The related issues of suppression and denial might also be challenging for those using oral interviews. When telling their life story or describing particular memories, an interviewee might suffer psychological trauma from relating stories that affected them negatively. They may refuse to share key aspects, such as their experience in war-time, when that might be what the historian is most interested in. There may be a conscious effort to refuse to discuss, or it may be a subconscious move, emerging as lack of memory of a particular event or time. Interviewees are also aware that they are potentially damaging their reputation or turning the interviewer against them if they reveal perceived negative aspects of behaviour or attitudes and so they may deliberately deny that these took place because they fear that they will be judged for contravening a moral code. Subjects' self-censorship is a real possibility especially when discussing sensitive topics and the historian must be aware that what is left unsaid is almost as important as what is being said. No single source by itself can give you an answer to every question, but by being aware of these 'silences', history students can construct a more subtle picture of the lives of people in the past.

Some scholars tend to assume that problems with oral testimony mean that it is weaker and less reliable than written evidence. However, this is not the case. With a rigorously constructed questionnaire and carefully chosen subjects, oral evidence can be very useful to the historian, both in terms of

corroborating material discovered in other sources and in providing new lines of enquiry that can be pursued elsewhere. Of course no interview should ever be assumed to be the 'last word' and must always be approached with caution and used in conjunction with other types of evidence. But there is no reason to assume that oral interviews are fundamentally flawed as long as you are aware of the conditions of their creation.

This chapter has discussed a diverse range of sources, all of which present opportunities and challenges to the historian. Before we look at some examples, let's list the key points to remember.

1 By examining the theoretical structures presented by film studies, we are able to explore fictional films and television programmes and incorporate knowledge obtained into our arguments.
2 Although they do not, perhaps, present the past as it really was, they tell us a great deal about the mentality of the time in which they were produced.
3 Oral recordings of interviews or music are also potent sources that allow a historian access to versions of the past that are often not easily available.
4 It is important to be cautious and to be aware of the flawed nature of television, film and audio recordings. They always tell only part of the story and may be crafted in such a way that deceives or misguides the listener.
5 However, such sources present vivid and immediate access to past and for this reason they must not be discarded.

Case Study One: Feature film – *The Searchers* (1954)

Movies are an excellent resource for those wanting to research the nineteenth-century American West. Throughout the second half of the twentieth century, Hollywood's most famous directors and actors were employed in making Westerns, a film genre that sought to depict a romantic version of the history of the conquest of the American West. It pitted white cowboys against savage Native Americans while simultaneously writing out of the story other minority groups such as the Chinese, African-Americans and even women. As such, these films are flawed in their depiction of the past and they reflect the values of a conservative and conflicted twentieth-century United States as much as telling the story of westward expansion.

The Searchers is one of the iconic movies of this genre. Made by director John Ford, whose name is synonymous with Westerns, and starring John

Wayne, the actor most associated with the genre, the film represents both change and continuity when we consider the trajectory of the depiction of Native Americans in Westerns. It was considered enlightened for its time in its depiction of mixed-race natives, permitting them to become key characters and giving them agency and voices within the story. On the other hand, the character of Ethan, played by Wayne, is racist and cannot bear the thought of his sister, who has been kidnapped by the Comanches, having lived with them for five years. He would rather see her dead than the wife of a native. Ford intended the character of Ethan to be viewed critically by the audience, so that they might reject his ignorance towards the natives, but in casting John Wayne in this role, Ford made a hero of the character. Wayne had played the uncomplicated US hero in so many of his previous films that audiences assumed that he was doing so again here. Also Ford used the Comanches in the film to convey his message; he does not think about their portrayal, their history and their agency, in and of itself. However, liberal Ford reacted to the events of his time and allegorically depicted the fear of miscegenation arising from the Brown versus the Board of Education Supreme Court decision of the same year, which in effect desegregated US universities and schools.

Historically, the film does not purport to depict a real event, although similarities can be drawn with the kidnap in 1836 of Cynthia Ann Parker by the Comanche tribe when she was a child. She lived with the Comanches for twenty-four years and bore Peta Noconah, her Indian husband, three children, including a future chief, Quanah. She was taken against her will by the Texas Rangers aged 34 and never properly settled back into white US society. One of the film's main themes is racial mixing and the fear of it. Mixed race relationships between natives and whites had existed since the first contact period and society's concern about them fluctuated over time. It was often possible for the offspring of such relationships, such as Quanah Parker, to excel because they were able to move easily across both worlds.

Case Study Two: Television series – *Blackadder Goes Forth*

The British comedy television series *Blackadder Goes Forth* is part of a group of series set in the historic past featuring the fictional character, Edmund Blackadder. This series features Blackadder in the trenches of the First World War. It uses satire, slapstick and wordplay to create humour but also attempts to deal sensitively with the subject of war and loss of life. The most famous episode in the series is the sixth and final one entitled 'Goodbyeee'. Having

avoided being sent to the front line for most of the series, Blackadder and his batman Baldrick (another fictional character who features throughout the groups of series) finally have to 'go over the top' as part of the forces trying to break the deadlock in trench warfare. As the characters enter the battlefield and a rain of machine gun fire falls upon them, the action changes to slow motion and the theme tune plays mournfully. The scene fades out to an image of poppy fields.

The episode aired to critical and popular acclaim. The entire series taps into the debate over the inevitability of massive loss of life during the war. The 'tommies' on the front line are depicted as heroic and enduring while the generals are ignorant buffoons, out of touch with the war, safe and dry in their offices away from the front. This mirrors the class-riven depiction of 'lions led by donkeys' that appeared in the 1969 musical and film *Oh What a Lovely War*. However, not all commentators were positive. As the debate reached fever pitch about how to commemorate the one hundredth anniversary of the start of the war, the then Conservative education secretary, Michael Gove, attacked the programme for giving out the message that the war was 'a shambles' driven by the mistakes of an 'out of touch elite'.

This programme is an excellent example of the poignant blend of comedy and tragedy achieved by subtle writing and careful acting. While it may not tell us anything new about the experiences of the British 'tommy' in the First World War, it is a way of heightening public awareness of their heroism and can be used as a form of public history, as a way of remembering and commemorating the past. Scholars must also be alert to the debates over the nature of the war and how such a programme contributes to it. Blackadder makes an excellent illustration of the popularity of the argument of the ineptitude of the war's generals.

Case Study Three: Radio Free Europe

This is a vital resource for those studying cold war Europe. Radio Free Europe and Radio Liberty were two separate radio stations (the recordings of which are now held in a joint archive) broadcast from the West targeting listeners behind the 'iron curtain'. Radio Free Europe was founded in 1950 and Radio Liberty in 1953. Initially, they were funded by the CIA with supplementary private donations, although from 1971 onwards, all CIA involvement ended. The content was local news items that were not provided by censored local providers but also cultural output such as reports of sport, leisure and music from the West. Journalists risked their freedom to work in Eastern bloc countries and also interviewed defectors in the West. A secondary audience

developed as well because the radio stations' output became an important source of information on the communist world.

The existence of these stations represented a threat to the communist governments that they targeted. Propaganda was released discrediting them and attempts to jam the stations were frequent. As local dissidents gained confidence and began to challenge the regimes, the radios became an important source of information sharing. When the Iron Curtain fell and communism ended in most of Eastern Europe, the possibility of disbanding the radios was raised, but the new democratic governments such as that under Lech Walesa in Poland wanted them to continue. The stations were not finally disbanded until the early twenty-first century. However, in recent years, broadcasts have begun again, this time to Afghanistan, Pakistan and the Caucasus region. They serve the same purpose – to act as a counterbalance to local extremist broadcasts.

Parts of the archive are only accessible to students with specialist language skills, Russian or Romanian for example. However, some broadcasts are in English and the accompanying documents are also available in English, such as memos and other early records referring to the founding of the stations that have been posted at the Woodrow Wilson Center's 'Cold War International History Project' online archive.

Case Study Four: Martin Luther King, 'I have a dream' speech

This source is vital for anyone trying to understand the role Martin Luther King played in the civil rights movement. In text version, his speech is moving and enlightening. King delivered what would become one of the world's most famous examples of oratory at the March on Washington for Jobs and Freedom in August 1963. The gathering was one of the world's largest political rallies, attended by approximately 300,000 people. The activist A. Philip Randolph had been planning a march for over twenty years, and the right time finally came in the early 1960s when the civil rights movement was at its peak. As well as campaigning for civil rights legislation, the marchers were also concerned with employment rights. There were several speakers on the bill, with King due to speak last. The 'I have a dream' section was actually a departure from his prepared notes as he partly ad-libbed in response to a cry from the audience from Mahalia Jackson to 'tell them about the dream, Martin'.

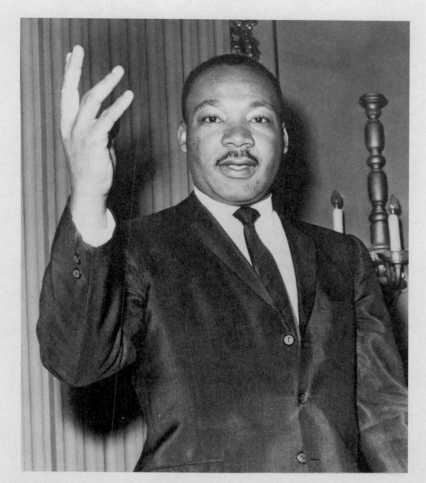

FIGURE 3.1 *Martin Luther King, photographed by Dick DeMarsico, 1964, World Telegram staff photographer. Library of Congress, New York World-Telegram & Sun Collection, Public Domain.*

The significance of the speech is that it became iconic at the time of the struggle of African-Americans to gain equality. The government's counter-intelligence agents in COINTELPRO, who began monitoring King, saw the speech as a crucial turning point, after which King was seen as the civil rights leader with the most significant influence. The speech was broadcast live on television (in fact many of the stations covered the march for the entire day, although TV executives had been fearful of televising the event in case of trouble), and recordings were made for radio broadcast too. King had honed

his powerful oratorical skills during his experience as a Baptist minister and he was able to precisely tap into the mood of the audience and of the nation. In his speech he describes an imagined America in which racism no longer plays a part in children's lives and black and white children can play together. King made allusions to Biblical texts and Shakespeare's *Richard III*.

Reading a text of the speech does not give one a true sense of its impact. Although of course its language can be analysed, it is not until you listen to an audio recording or watch a recording of the television broadcast that you can get a sense of King's interaction with his audience and of King's true power as a rhetorician. His use of tone and pace drew in his listeners and he and they built to a crescendo (known in Greek rhetoric as a 'peroration'), the sense of which is difficult to understand while looking at the written text.

King's speech provides students with an excellent primary resource to illustrate his significance within the movement and the reasons why he rose to national prominence. In analysing the speech's reception by the media, we see how civil rights issues became part of the mainstream American culture. No longer was this a minority concern; following the March on Washington for Jobs and Freedom, every American had the language of civil rights and freedom on their lips.

Case Study Five: English broadside ballad archive

Broadside ballads are songs printed on single sheets of paper, sometimes accompanied by the name of the tune to which they were to be sung. An example of this is the 'Innocent Shepherd and his Crafty Wife', reflecting the sometimes bawdy nature of ballads (a pun on the word 'cold' and 'cuckold' is the main point of humour in this song) and their addressing of gender politics of the period. This particular ballad is in the National Library of Scotland Crawford collection. It is printed but undated. The text version is accompanied by a vivid woodcut image showing the 'crafty wife' with her breasts exposed. This does not necessarily have the connotation of sexual availability as the fashion for exposed breasts also connoted status and was worn by monarchs. The subject matter of ballads can be various, from the trivial, to the religious to the political. They can be accessed online with a PDF of the original broadside accompanied in some cases by a modern recording of the ballad.

As with the King speech above, it is possible to get a sense of its significance simply by reading a transcript of the ballad. But hearing a recording of what it may have sounded like of course adds another dimension to the interpretation.

FIGURE 3.2 'Innocent shepherd ballad', National Library of Scotland, Crawford 1056. Reproduced by permission of the Balcarres Heritage Trust/ National Library of Scotland.

However, scholars must be cautious here. The recording is a modern rendering of the song. While we can say that this is similar to its impact in the early modern period, we cannot precisely recreate the exact conditions of its original performance. It is an illustration, an example only. Whereas we can use the King recording directly as evidence from the period, as a primary source, in this case the recording gives a sense of the song, but does not allow us direct access to it. However, sound is an important part of history and is something that has recently become a topic of debate among scholars. In the era prior to sound recording, in order to access the soundscape of the past, we must recreate it using methods such as these ballad archives.

Case Study Six: Oral history – the WPA ex-slave interviews

One of the largest oral history collections freely available to students online has a fascinating history itself. During the Great Depression of the 1930s, Franklin Roosevelt's New Deal government under the auspices of the Works Progress Administration sent out artists, photographers, writers and researchers, of whom, all would be otherwise unemployed to record the oral testimony of many thousands of Americans with a view to writing the histories of different

regions of the country. The programme was known as the Federal Writers' Programme and included both white and African-American researchers and writers, although rarely in an integrated context. Former slaves in seventeen states were interviewed between 1936 and 1938 and constituted a considerable part of the interviewees, with over 2,300 recorded testimonies, accompanied by 500 photographs. These accounts provide a crucial archive in the study of slave life and experience because slaves were rarely literate and so they left few first-hand accounts written during the slavery era.

However, these accounts are problematic. Historians John Blassingame and Lawrence Levine have written extensively on this. Firstly, they were collected seventy years after the end of slavery. Those recalling their experiences were young children at the time. Their memories may have become distorted and their experience of slavery would have been very different from that of adults. Another problem is the situation in which the interviews were made. White interviewers conducted almost all of the interviews, and the power dynamic between interviewer and interviewee affected the way ex-slaves recorded their memories. Race relations were not good during the 1930s and it is likely that former slaves felt inhibited in revealing their true memories. Another problem is the way that the interviewees' speech patterns were recorded by the interviewers. The interviewers were not trained linguists and therefore their recording of black speech patterns is random. However of greater importance, this recording reveals the racism of the time and the long history of white mimicry of black speech patterns, used in a derogatory manner. The white interviewers were tapping into this tradition rather than recording the ex-slaves' speech in a neutral manner.

These interviews are available in digitized form online. Some accounts consist of a few lines, others record detailed testimony. For example, the record of the interview written down by Mrs Genevieve Chandler of Murrell's Inlet, South Carolina with the former slave, Louisa Brown, is seen online as three pages of typewritten script. In her interview Brown describes her wedding and life on the plantation, but this would have been in the years after the abolition of slavery as Brown was born as she said 'in time of reb people war', i.e. around the time of the American Civil War. Brown's testimony also outlines some of the songs that people used to sing on the plantations, typical slave folk songs such as 'I wish I had a hundred head o' dog, and half of them wuz hound, I'd take 'em back in my bacco field, and run the rabbit down'. This shows that the WPA narratives are useful to scholars working with music as well.

Because of the lack of alternative sources available to help students of slavery access first-hand accounts, these interview transcripts are an amazing resource. But it is important to be cautious when using them and to understand the particular conditions of their collection. Oral testimony is no more flawed than any other type of source as long as the scholar asks critical questions of the material that he or she is working with.

CHAPTER FOUR

Material Culture and the Built Environment

Aim: This chapter will explore the ways that you can incorporate two different types of historical evidence into your work. First, material culture, the artefacts and 'things' of history and second, the built environment historic evidence that we find in the world around us. We will also examine how these two source bases have been interpreted by the heritage industry, which is vital to understand in order to successfully interpret these unusual sources.

Material culture: The theory of 'thingness'

For many people interested in history, artefacts play an important role in understanding the past. Somehow these things embody something real about the past. They can talk to us directly about former times. They were actually there; they not only provide clues about history, they *are* history. However, history students must be very careful about using such resources unthinkingly. We must always remember to ask critical questions of our sources and objects are no exception. We must determine why they were made, who by, where and when. We must put them in the context of the stylistic and technological developments of the time. And we must ask what do they mean? How were they used? Were they valued? Were they unusual or commonplace? What can we learn about people's behaviour in the past from them? But we must also analyse why it is that these

objects have ended up here. Who has decided that this particular object is important enough to be saved, preserved and exhibited or sold?

As Karen Harvey has argued, 'things' have not been well studied by historians thus far. Artefacts have remained peripheral to the discussions of most historians.[1] For the last two hundred years, historians have focused on manuscript and printed documents and books in order to learn about the past. These textual sources have dominated research to the detriment of the other types of source that this book has highlighted. 'Things' have been the preserve of archaeological study. However, in recent years, historians have realized that 'things', or material culture as it is more formally known, have a great deal to tell us about the experiences of people in the past. As with images, material culture allows us to get closer to the past because it accesses different senses and thus speaks more immediately to our imagination. We can empathize more easily having seen or touched something from the past, perhaps smelled or even tasted it. Ludmilla Jordanova summarizes that the look of the past gives us rich historical evidence with which to develop our investigations and ideas.[2] Like oral histories, material culture can also allow hitherto neglected historical subjects to speak. For many centuries, historians felt that textual sources were only able to speak to us about the literate few. Then using post-modern literary critical methods, the voice of the subaltern* was discovered within such texts. Similarly with material culture, we have to ask whose history is being communicated to us? Is it representative of the lives of the elite or the ordinary people, or could it possibly be both, a shared experience across economic boundaries? Those who have no voice when historians resorted to examining only textual sources can be rediscovered using material culture. This idea builds on the work of James Deetz whose book *In Small Things Forgotten* shows how, using material culture, it is possible to reconstruct the histories of Native Americans and African-Americans who leave little evidence in the written record.

Women's history can also be illuminated by the examination of material culture as their roles within the domestic sphere, unrecorded in many textual sources, can often be overlooked by scholars. By looking at clothes, furniture and other everyday artefacts, we can reveal the decisions taken by women in the past as well as their experiences and opinions. We can also learn more about their work, both at home and later in small workshops as manufacturers of goods such as textiles. The study of artefacts can align one woman or household aligned within the context of global trade networks and of trends in style and aesthetics. 'Things' unite micro and macro histories.

* Definition: subaltern, a person from a lower order of society, somehow disadvantaged or discarded by the traditional historical narrative.

So, if it is the case that material culture has so much to offer and enriches our understanding of the past, why have historians been reluctant to engage with it? Partly it is a lack of confidence in knowing how to interpret such sources, and therefore this chapter will aim to give you the intellectual tools that you need to do that. It is important that we see this not as a separate type of history but rather that we strive to integrate the study of material culture into 'ordinary' history by simply making our arguments using a different type of source evidence. And of course as we have seen in previous chapters, it is crucial not to take these non-textual sources in isolation but to use them alongside the written record.

Methodology

Let us examine how you 'read' material culture. We think we understand, for example, what a tankard is or what a cloak is, but how do we interpret them as historians? Just as with images, we have to consider them in their historical context. It is wrong to assume that material culture is emblematic of its period. Yes, an artefact may be a product of a certain period, but it has a different meaning depending on its status, for example, as a luxury or practical item, or whether it is typical, unusual or even unique when compared to similar artefacts. Something may have survived and been collected and preserved because it is highly unusual and definitely not typical. Therefore, what can we extrapolate from a single rare object about the lived experience of many people? In that case, we must begin by describing the creation and use of that particular object. We can learn about its purchasers, about why they chose to be different in buying that unusual thing, and what statement they were trying to make about their status and values in doing so. And in comparison with similar, more common artefacts, we can make deductions about taste, luxury, consumption and economics.

There are three ways to think about the methodology of approaching artefacts. First, understand the supply-side, second the consumer-side, before finally understanding and describing the physical nature of the object itself. Focusing on the influences on the supply-side will allow you to consider the manufacturers and the distributors of the object and you can also consider the materials and techniques used in the creation of the artefact. The choices that manufacturers make are determined by the availability of raw materials, by current fashions and style, and by economic factors. It is immediately possible to place your single object in the broader historical context of global trade networks.

Considering the influence of consumer-side aspects alerts us to the role of retailers, advertising and the perceived desirability of the object. Key questions to consider include how was the object marketed, where was it sold and by whom, and finally for what purpose was it bought? The answer to the last question is a complex one and involves a historian

becoming versed in the methods of economics, marketing and psychology. But two distinct motives emerge for the purchase, borrowing or stealing of a particular item: the practical and the aesthetic. These motives are not mutually exclusive and often function alongside one another. An item usually served a purpose in people's everyday life in the past and its practical use must be considered. But in making the purchase, the buyer is also making statements about his or her fashionableness, cultural awareness, social status and sometimes gender, race or religious identity. By addressing these questions, you can demonstrate the ways in which a single artefact belongs to a broader cultural *milieu*.

Fundamentally, when dealing with objects, it is vital to be able to systematically describe what you see as a precursor to analysis. Sometimes when you encounter an artefact in a museum collection, it will already have been catalogued. However, if you find something yourself in an auction or encounter it in someone else's private collection, it may be the case that the 'thing' is still undefined. You need to accurately describe it before going on to relate this description to its use. Of course, as shown above, part of this job is to comprehend its manufacture and the materials out of which it was made. But the definition also involves describing colour, taking measurements and ascribing a generic category to the item. Taking photographs is a very important part of recording it and these are useful later when preparing your analysis. If possible, use a ruler in your photograph to indicate the size of the object that you are cataloguing.

As you undertake this description, be aware that it is impossible to render a neutral, scientific description. Your own aesthetic views and opinions about the artefact and its use will creep in. But by attempting a rendition that is as basic and descriptive as possible, you will provide yourself and other researchers with useful data for analysis. Be consistent in the language that you use, especially if you are describing a number of items. There are detailed guides illustrating how to do this work, such as the online Cataloguing Cultural Objects manual.[3] This manual is designed to guide cataloguers who are recording the nature of physical objects in electronic databases. For your purposes, you need to be as precise but less detailed. The crucial categories for you to consider are as follows:

Artefact type
Title
Creator
Date
Style
Location
Measurements
Materials
Techniques
Description

By completing these descriptors for every artefact that you use, you will be able to gather consistent and usable research materials. This description will then act as part of the raw evidence for the assignment that you are undertaking: you then have to proceed to your analytical work about the significance of the object.

As with works of art, for all material culture it is important to understand the aesthetics of the period, that is, how people at the time responded to the appearance and design of the goods. No artefact, however practical, is value-neutral. What some cultures have considered to be desirable or luxurious have been considered negatively by others. Consumption and luxury were considered sinful by some groups; for example, the Puritans in seventeenth-century England. These beliefs must be understood before we discuss, for example, the goods used in the kitchen of a Puritan home in East Anglia or in New England. Textual sources can also be considered in this way and there was a discourse in sixteenth-century English print culture that saw printed material itself as uncouth and argued that the medium was a morally dubious way of conveying ones ideas to the public. It is also important, as we saw in Chapter Two on images, to understand the influences of the aesthetics of the classical world and religion on the creation of things. Later with the rise of consumerism and ideas of conspicuous consumption and luxury in the long eighteenth century, we see fashions in particular goods change.

Another way of imagining the importance of a particular object is by conducting what Karin Dannehl called 'an object biography'. She recommends examining one single artefact and trying to piece together its life story from the conception of an idea or a fashion, through to the production and use of the artefact, down to its preservation in private hands or a museum. Rather than trying to examine many pieces of material culture and doing comparative work or attempting statistical analysis, this life cycle approach can reveal many surprises. At all stages of the life cycle, it is important to locate the place where the source was and this is where this chapter's interest in material culture and the built environment come together. Understanding where an artefact was used, stored, found, thrown away can help us to interpret it. For example, in the early modern period it was common for house builders in both Europe and the United States to secrete, in wall cavities and chimneys, objects that would act as spiritual talismans or that would have other ritual purposes for the owners or occupants of the house. Such objects include coins, clay pipes, shoes, pieces of cloth, and also dead animals, especially cats, were used. The practice became rarer after 1800, but some goods were secreted as late as the early twentieth century. Witch bottles were also used to protect the household by warding off evildoing by local witches. These bottles were usually Bartmann or bellarmine jugs, decorated stoneware decorated with a bearded man that held urine, nail clippings or pins and needles. They were given to the household by a local witch or wise-woman, and the theory was that the negativity created by bad spells would be attracted and absorbed by the contents of the jug, thus leaving the household safe.

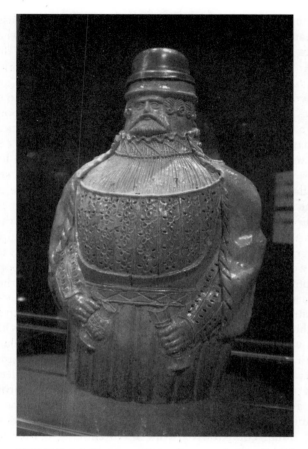

FIGURE 4.1 *Bartmann jug, photographed by David Jackson distributed under Creative Commons License 2.0. Public Domain.*

Built environment: Seeing it through a historian's eyes

A real challenge to the scholar is rendering the familiar, the everyday, as if seeing it for the first time, in order to observe it and its significance. This can help us to interpret material culture but is often even more of a challenge to do successfully with the built environment. We are so familiar with the places that we live in that we do not see the layers of historical evidence that exist before our very eyes. Sometimes museums or councils direct us to observe the historical nature of a place, for example, through

tourist paraphernalia such as the blue plaque scheme. But other places not designated as historically important can also tell us something about the way people lived in the past. Even your own home can be used in this way, and you do not have to live in a centuries-old thatched cottage for historical evidence to be present.

Understanding the creation of the built environment is the job of architecture scholars. They have developed theories of changing architectural tastes that mirror aesthetic trends for the other arts. For example, the history of architecture employs terms such as classical, Palladian, regency or rococo to describe European developments in building style during the eighteenth century. As well as styles, changing building materials and techniques are part of the analysis. Historians must be able to borrow these methods and they also need to answer the 'why' question. What is the purpose of this building, how was it used by its residents? How has the building's significance changed over time? What can it tell us about the street, town, county and country in which it is sited? Many types of buildings can be incorporated into your studies. Houses are one particular area of focus but also of interest are shops, pubs, factories, municipal buildings, prisons and hospitals. In all of these cases, the nature of the physical structure can be related to the use of the building.

It is important to learn the language of architectural description of the built environment and this can present a challenge because of its unique terminology. But as well as being able to name a particular feature, it is also important to understand why it was added, whether for functionality or style. Similarly with room use; in ordinary people's houses, room layout is relatively simple; however, the uses that each room was put to may be unfamiliar to us. For example, many lower status houses did not have a separate kitchen until the early part of the twentieth century, while in wealthier households the location of the kitchen varied considerably. In the southern states of the United States, for example, kitchens were usually detached structures situated next to the main house, kept separate to minimize fire risk. Other rooms had multiple purposes, such as the 'parlour' which was not only a public room for entertaining guests and performing rituals of sociability but was also used for the conspicuous display of luxury goods.

The choices made by landowners and landscape designers in creating an estate also reflect the dual purpose of utility and self-fashioning. Plantations in the southern US colonies were designed to house both the wealthy white family but also their white servants and black slaves. In this case the layout of the built environment, the house itself but also the entire estate, reflects the attitudes of the owner towards his staff. Many plantation owners chose to site their slaves' quarters at a distant part of their estate, out of sight of others. This choice reflects the psychological turmoil that slavery caused among many whites and situating slave homes away from the public gaze allowed them to push slavery out of their mind and dismiss concerns they

may have about the treatment of their chattels. Their public display to their white neighbours included their grand house and the long drive leading up to it but not their slave property. Others, such as the owners of the Mulberry Plantation in South Carolina, a painting of which was completed by Thomas Coram in 1800, took a very different approach and proudly displayed their slave property to all friends and neighbours approaching the house. They did this by situating their slaves' quarters along the main drive leading up to the plantation house. The owners of Mulberry felt no psychological conflict in prominently presenting their slave property for the observation of others, defining their own success and sense of identity through their owned human beings. They felt confident that the level of care offered to their slaves in the form of the accommodation provided would stand scrutiny by any visitors.

To understand the built environment, we must not only work with a single building but also understand how groups of buildings were arranged into settlements. This was often done in reaction to specific environmental situations, so a consideration of the impact of the natural world is also important. Some settlements emerge organically, with little prior planning, in response to resources, whereas others are planned from scratch and then develop in line with economic and demographic influences. Some settlements change relatively little over a period of centuries, whereas others, such as towns in Europe that were bombed during the Second World War, are almost unrecognizable. Observing the built environment and the historical layers of its development is most easily done by walking around the area in conjunction with an analysis of historic maps and, for more recent history, old photographs (although of course please bear in mind some of the issues that old photographs raise; see Chapter Two).

The abandonment of entire settlements or individual dwellings is also an important subject for study. This tells us about the fortunes of a particular family or community, about environmental change or about other events acting on the environment. An unusual example of abandonment is the forced removal of inhabitants in order to reclaim the land for agriculture, for a grand estate, or for military purposes. In 1942, over a thousand villagers from Stanton, Tottington and West Tofts in West Norfolk were forced out of their homes in order to make way for the Breckland Battle Area. This region made it possible for troops to train using live ammunition. The War Office had attempted to use the remote region without first evacuating the villagers, but after a fatality, the removal was enforced with the support of the landowning aristocrats, who persuaded their tenants that there was no alternative. After the Second World War, there was a hope of return for the villagers but the emerging Cold War threat from the Russians meant that the Battle Area was still required and in fact it is still in use today.

When you go into your local area and make observations about the built environment you will naturally bring your own prejudices and assumptions

to it. The architectural critic, Nikolaus Pevsner, whose 46-volume series of books on the *Buildings of England* grace the bookshelves of many households, did not simply describe the environment that he encountered but he commented on it, often being wittily critical of the lack of style in the buildings that he witnessed. Houses and civic or religious buildings featured prominently in Pevsner's observations but also worthy of study are places of work such as factories and buildings with a more practical purpose such as prisons and hospitals. Sometimes such buildings have fallen out of use and have usually not been preserved as they once were nor have they fallen into decay but instead have been converted to new uses, often as accommodation. Despite this change of use, the buildings can still be analysed for their design, materials, dimensions, situation and former use. These lessons can be learned when we come to interpret other historic buildings such as churches. These have not been artificially preserved to reflect the history of one era but have changed just as the religious trends of the monarchy and people have changed. Observing the impact, for example, of the Reformation on the church structure, furniture and decoration is very rewarding, but it also must be remembered that the physicality of churches has adapted to change ever since, to Victorian gothic revivals or to contemporary needs to accommodate younger congregations.

Buildings are not the only structures in our towns and villages worthy of study. Angela Gaffney has worked on the historical significance of monuments in the mining communities of South Wales. Every parish in England and Wales has a war memorial to honour the dead of the First World War, and later the fallen from the Second World War were added. These memorials were erected in response to the needs of a grieving population for somewhere to remember and to pay their respects for those who gave their lives for their country. The mining community of Senghenydd, near Caerphilly is no exception, and its memorial records the names of sixty-three men and boys who lost their lives between 1914 and 1918. However, until recently, there was no memorial for the 439 men and boys killed in October 1913 in a mining gas explosion in the town – the worst single loss of life in the history of mining in the UK. Of course, sheer numbers do not always determine a community's response to the loss. But it seems unusual that the town did not memorialize the lost miners until a century later when a bronze statue and a memorial garden to commemorate all lost miners was unveiled at the pit head. Why was a memorial not erected earlier to the men who died in the Universal Mine? The issue of past historical wrongs and commemoration and memorialization is a very controversial one. In this particular case, the lesson had not been learned at the pit, because a decade previously eighty men had died in a similar explosion but working practices had not changed. Commemoration in public memorials of other tragedies such as that remembering the slave trade in Lancaster have also caused disquiet because of links between historical slavery, modern racism and modern

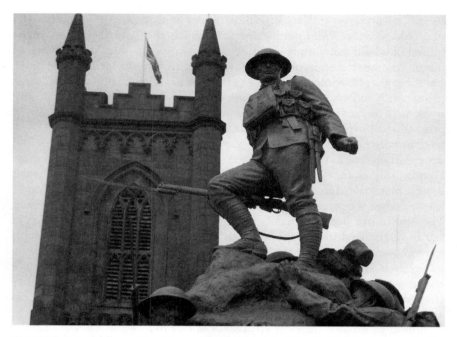

FIGURE 4.2 *Oldham War Memorial, photographed by Keith Etherington. Public Domain.*

bonded labour practices. War memorials have never caused a similar attribution of blame, although the names of the 306 men who were shot for desertion during the First World War, mostly due to what we would now call post-traumatic stress disorder, have not been allowed onto war memorials. The public mood about this is changing though and at the National Memorial Arboretum in Alrewas, Staffordshire, a memorial to the 306 was unveiled in 2001.

Public history and heritage

As the example above shows, the built environment is not only a site for historical study, an unconscious revealer of times past – a primary source – but also one that can provide evidence of how we as a nation, community or as individuals engage with the past by self-consciously recalling our remembered past. So, in order to understand how best to use these places and spaces in our own historical work, it is vital that we become aware of how those in the heritage industry use, enhance and manipulate the places around us in order to create a story about our past. Often, the places we visit and the artefacts we examine have been

presented to us in a heritage industry context and we must understand that their message about the past has been mediated by organizations and an industry with their own agendas.

This forces us to consider history on a wider scale. We no longer focus on how you as an individual student learn about the past in a university setting with the lecturer and professor as arbiters of knowledge. When examining public history and heritage resources, it is important to understand that there are other power structures at work. Who holds the authority in museums and galleries? Equally, consider the role that 'history' plays in the lives of the many people who do not study it at university. Those people go to museums and galleries for pleasure; they are the non-specialist but enthusiastic audiences for whom history is an important hobby or mode of entertainment. They may be tourists passing through an area or they may be local people with a real sense of investment in their local sites of historical interest. Their response to artefacts and to the built environment is important because things and places are presented by the heritage industry with this general public in mind. David Lowenthal argues that there are three ways that we access the past: memory, history and relics.[4] First, we explore our own personal memories; second, we access the collective written historical knowledge about the past; and finally we examine 'relics' such as buildings and artefacts. Let us explore how you might use 'relics' as evidence while understanding how the other two categories of 'memory' and 'history' affect our interpretation of them.

Earlier in the chapter, we discussed the life cycle of an artefact, from creation, to sale, to use, to conservation. At the end point of that cycle, you must consider why this item is in your hands today. The answer may be that you found it in the ground, in a relative's house or in a shop. But equally as likely, you are examining an object in a museum, gallery, stately home or other site of heritage. When assessing the significance of the object you need to think about how and why it has been collected and preserved. Who has done the collecting and to what end? Often, artefacts in museums and galleries have been donated for the benefit of the public. This information will usually be available to you via a museum catalogue or in conversation with a curator. At some point between the last use of the item and today, someone, a private collector or a museum curator will have decided that this object is worth saving and preserving. Why? Is it because it is unique, unusual, or challenges our assumptions? Or alternatively is it because it is typical, it is representative of an entire type of artefact? Does it become symbolic, representative of other artefacts now lost? To understand this you need to know what place the artefact has in the collection. Is it displayed for public consumption? If so, what is the message that it intends to convey? What other artefacts surround it? Or is it present in the collection of a museum but not displayed? If this is the case, then why? Is it somehow out of fashion, complicated, unable to give a simple message to an uninitiated audience?

Might it have been collected in the museum simply to be preserved, to ensure its survival? If this is the case, then we come back to our original question: does that mean that it is extremely rare and unusual? What about the issue of non-survival, of a silence in the artefact record? Preservation of artefacts is rarer than destruction, alteration or loss of items. It may seem odd to think about analysing something that is not there. After all, how can you study something that does not exist anymore? Surely this is an impossible task akin to asking you to study a document that was never written. But actually, historians are interested in the silences, the lack of voices within written documents. For example, in court accounts, the rendering of the words of the accused into formal legal language does not stop scholars from trying to reconstruct the lives of the poor and disadvantaged who found themselves in court in the past. The illiterate subalterns in all societies, despite their words being lost to us, are now a major subject of historical study. Similarly with missing artefacts, the fact that they were not preserved tells us something about values of people in the past and since. The example given by Glenn Adamson is of footstools. He tells us that footstools had associations with sofas in the eighteenth century, innocent enough to us now but with connotations of idleness, indolence and uncontrolled sexuality in the past.[5] It is easy to consider certain items as ephemeral* in the same way as we might, according to cliché, think of yesterday's newspapers. But under some circumstances, people collect and preserve yesterday's newspapers. They exist in the archival record today. So, it is the historian's job to consider under what circumstances and for what purpose items were preserved or were not.

Of course, looking at the intentions of the museum curators and collectors is only half the story. Just because the designers of a particular exhibition intend a display to convey a certain message does not mean that it will do so. Audiences bring their own preconceptions and interpretations to the artefacts that they view (just as they do to textual materials). Sometimes, for example, when viewing social history exhibits of the twentieth century, individuals react emotively to certain artefacts because they were part of their own personal past history. They can remember these items from their own homes and childhoods. This realization is often accompanied by the humorous assertion that they themselves have become part of history and that they must be getting old. In this way, as Christine Johnson suggests, museums can truly become 'ours', part of a joint historical memory in which seemingly randomly chosen artefacts can become personal heirlooms of the individuals as they proceed around the galleries.[6] These objects can force us to reconsider our own identities and memories and to change the way we conceive of our own past.

* Definition: lasting for only a short time, something that is transient.

As well as challenging our sense of ourselves by making us identify with an aspect of the past, artefacts can actually discomfort us and make us reject our memories or feel alienated from them. As Sherry Turkle has stated, some objects are so powerful that they evoke distance and hostility and not closeness and familiarity.[7] Negative responses can at times be deliberately crafted by the curators, who, for example, wish their audience to feel anger or pain in response to viewing a collection of shoes left behind by Holocaust victims. On other occasions, artefacts created distance and horror in an individual because of particular memories, for example, of abuse or divorce, personal to them and their immediate family. Other responses can be conditioned by the experience of prejudice and violence felt by a particular gender, race or ethnic group.

The contested messages that audiences take from artefacts at personal and community levels also are reflected in tensions at national and international levels. The ownership or curatorship of certain artefacts is highly controversial and leads to international tension. This is because artefacts are powerful tools in the heritage industry and can attract tourism and therefore money to a particular town or country. But apart from the pragmatic issue of money, there is also disagreement over who might be the best custodians for particular things, especially those fragile pieces of material culture that need to be kept in special conditions and given care to preserve them from further disintegration. A final point of contention is that the control over artefacts has great symbolic value. It allows particular countries and organizations to claim that such goods are part of 'our' history and not 'yours'.

The most notorious example of this sort of disagreement is the Elgin Marbles, a controversy that has raged for two hundred years and has led to tensions at the governmental level and a vitriolic scholarly debate. Even referring to these artefacts as the 'Elgin' marbles is problematic. The control over these items has hitherto rested with the British Museum since between 1801 and 1812, when Lord Elgin, with the supposed permission of the Ottomans who were then running the Acropolis as a fort, seized and sold the marbles to the British government. The British claim rests on the argument that Elgin had permission to remove the marbles and that the London museum is better resourced to preserve and care for them. More tourists and visitors will have access to them there because it is free to visit. The significance of these artefacts, the case goes, is greater than merely to the national history of Greece: it is worldwide. On the other hand, the Greek argument is that for millennia, the marbles were 'theirs'; they were manufactured in Athens and were situated in the Acropolis, and form a single piece of artwork. They were stolen by Lord Elgin, whose dated colonial attitude, that the inferior Mediterranean authorities could not care for the marbles, is still in evidence among the heritage professionals in Britain today. And the values and purposes of Lord Elgin are celebrated by the very

presence of the marbles in London. There is a precedent for restitution. Museums from other European countries have donated fragments from the Parthenon marbles back to Greece.

So, it is important to think about heritage in terms of power structures. Who is in control of our history? Who shapes our conception of the past? Archivists and curators do operate in a position of power in this system. They are able to present a certain vision of the past that will entertain and entice visitors but archives are not value-neutral. Museums define and give cultural meaning to objects. Artefacts have not simply been preserved because they are 'interesting' but because the messages they tell about the past fit with the ethos of the collection or the museum in which it is sited. This is history from above, in which the visitor is told what is important about the past, and alternative narratives are silenced because of a lack of material cultural evidence. Iain Robertson argues that there is 'an authorised heritage discourse', a version of the past that is acceptable to those in the heritage industry.[8] This discourse often emphasizes the local, the domestic, but also most crucially and controversially, the idea of a lost golden age. This romanticization of the past appeals to public, non-expert audiences, reinforcing their own sense of nostalgia and the desirability of a past just out of reach. This also has political ramifications because the nostalgia also often claims that the nation's heyday has now past and recalls a more glorious national history. This appeal to a golden age is especially well received during times of social and economic dislocation and is reinforced in other types of sources such as film and television depictions of the past. Because audiences' views are reinforced and not challenged, they will pay money to see this sort of exhibit. Historians' lack of consensus about the past and the existence of voices of resistance challenging the idea of a glorious past play no part in this conception of history. A way of avoiding this hegemonic heritage discourse is to acknowledge that curators and collectors are not the only ones with a voice in discussions of the creation of a heritage past. The past is not only housed in country houses and museums but can also be found in your loft or living room. You as an individual have just as much right to decide that an object is worthy of study as a curator or collector does.

But the power of the heritage industry is strong. Heritage is increasingly not only an industry but also a business and there is an expectation on the part of government and heritage personnel that business models will be applied to the industry. This means that transcending entertainment and education, economic imperatives are brought to the fore. This can actively distort the way that the heritage industry constructs 'the past' because it is concerned with being cost-effective and generating money. The funding situation reflects these concerns, with projects being funded by government-sponsored bodies based on how lucrative they will be.

Funders are most concerned with how the greatest benefit to the greatest number of people can be achieved for the smallest outlay. These models mean that money can be wasted when organizations rush to spend budgets before the end of the financial year, or before the end of a funding term, rather than spending the money wisely to ensure the best outcome for the heritage site.

In some cases, the stories that the heritage industry tells about our past have become our history, ironing out the complexities in the historical narrative. Their purpose as an industry and a business is to make money by appealing to certain impulses, reinforcing certain ideas skews the stories that they tell about the past. The past depicted in the heritage industry becomes almost a parody of the past itself. An obvious example is the room at a country house – a venue that has come to epitomize the history of the English people over the last couple of centuries. Apart from refusing to interrogate the power relations, divisions of class, gender, ethnicity that existed within the country house setting, these rooms capture a particular type of past. Depicting the rooms in the way that people lived in them would not appeal to visitors who are now used to a stylized version of what to expect in a particular room in a country house.

The spaces within our cities and countryside that have been taken over by the heritage industry are often reinvented without consideration for their actual histories. Declining industrial areas, in formerly wealthy regions and cities, are commandeered by the heritage industry as museums and galleries. Telling the story of the region's decline, and the political and economic reasons behind it, becomes less important than the new purpose of displaying a version of the nation's past. This change in use unquestionably brings a new purpose to an economically deprived area and might even bring tourists to a site that would otherwise have been destined to lie fallow. But it prioritizes one artificial, controllable version of the past that is saleable to a tourist public and neglects, even suppresses, another history in doing so. A useful distinction highlighted by Robert Hewison is that between two types of heritage behaviour: preservation and conservation.[9] Preservation, he argues, is the attempt to present artefacts in the same context that they operated in when used in the past. An example of this is at steam heritage railway, when although it now runs only for tourists and no longer for commuters, a steam train runs along a short section of track in a similar manner to its original branch line duties. Although the train maybe polished and shiny, whereas in its real working context it would have been grimy and neglected, it still performs the same function. The steam engine, rolling stock and stations are preserved for aesthetic reasons because the world without an example of a steam train would be a worse place, and many thousands of paying visitors per year agree. Conservation

on the other hand, acknowledges that historical contexts change and time causes decay and decline but that things and places can be adapted to new purposes. An example of this is turning an old factory into a museum. The factory as a building will survive because it has adapted to a new purpose. However, the factory's historical context and meaning can become lost in the process.

As well as entertaining, museums have a strongly pedagogical function, both explicitly through the presence of an education officer in even the smallest of museums and implicitly in the imparting of knowledge to visitors of all ages. The museum and its curators are often depicted as the holders of knowledge and visitors as the blank canvasses to be educated. Students of objects and the built environment must be careful to be aware of this distorting influence of the heritage industry that promotes, at best a partial, and at worst an inauthentic, version of the past. They must move outside the museum and the gallery to find their own sources and their own historical places of interest, and heritage sites and 'things' must be used only with caution. However, I do not want to leave you with a wholly negative impression of the heritage industry and in particular those who work at individual heritage sites. In many ways, they do a laudable service within challenging financial constraints but with an enthusiasm and love for history that is admirable. Care must be exercised, as with any primary source, but do not abandon the idea of incorporating evidence from heritage sites into your work as long as you are alert to the hegemonic structures that influence the site's development.

This chapter has given you the tools with which to interpret 'things' that you encounter whether in a museum or at home or elsewhere. It has also allowed you to consider places, the built environment, as a source. Always be an alert and active observer of both these types of sources and you will be able to access the messages that they have to tell about people's lives in the past.

Before we look at the case studies, here are the key points to take from this chapter:

1 Think about whose history an artefact reveals.
2 It is important to understand three aspects of an object – its supply side story, consumer side story, and its material nature.
3 Understanding the built environment, individual buildings and the layout of the streets and settlements through architectural styles only tells half the story. Think about how ordinary people used and experienced these places.
4 The heritage industry tells a variety of stories about the past; be critical and analytical when approaching a museum or heritage site. What is the message that it is trying to convey about the nature of history?

Case Study One: China for the Portuguese market – Ewer, 1520

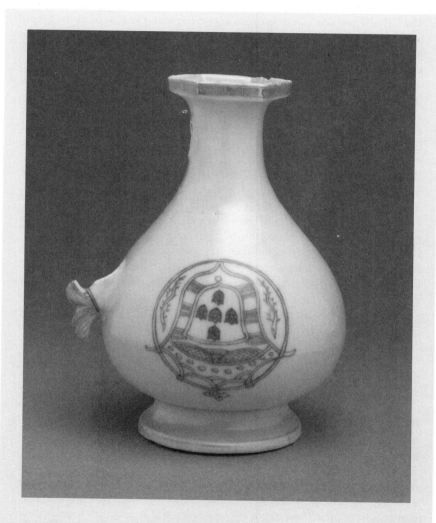

FIGURE 4.3 *Chinese ewer for the Portuguese market, 1529, Metropolitan Museum of Art, New York. Image reproduced through OASC (Open Access for Scholarly Content).*

This item is to be found in the Metropolitan Museum of Art in New York as part of the Helen Woolworth McCann collection. It was purchased by the museum in 1961. It was manufactured in China in roughly 1520. It is a piece of ceramic made of porcelain with cobalt blue illustration under a transparent

glaze. It is an ewer, a large water jug. In design it resembles ewers manufactured for the Islamic Near East market. However, this one was designed for the Portuguese market because it is illustrated with the Portuguese coat of arms. The Chinese manufacturers, though, unfamiliar with the coat of arms design, have mistakenly printed it upside down! Many other porcelain items were produced at the time for the same market but with Christian iconography such as the IHS monogram. It is in excellent condition.

So, what is the historical significance of this item? Robert Finlay claims that this is the earliest extant item to reflect the Portuguese market in blue and white ware. Therefore, it is illustrative of the earliest period of trade between China and Portugal in porcelain. Portuguese ships had reached China in 1517. This did not provide their first exposure to porcelain, though, as it had been traded via land routes throughout the Ming Dynasty. Portuguese Jesuits were active in the Far East on the coasts of China and Japan, with a view to converting the natives but also engaging in trade. So, some traders did not represent a particular nation but rather the Church. Portugal at this time was gaining wealth and status, beginning to participate in the African slave trade and, from 1500 onwards, settle the colony of Brazil. Luxury wares such as this became very popular throughout Europe. The form of the vessel is fascinating because it is neither Chinese nor Portuguese but rather shows that the Chinese manufacturers, uncertain, at this early stage of the trade about what Portuguese market might appreciate, instead presented them with an ewer that would appeal to the Islamic near east. The error on the design further reinforces this idea of unfamiliarity between the two trading partners. However, this is globalization at work; the ewer is a truly global object but one that shows the flawed nature of early commercial relationships. Although it is the only surviving one of its kind and date, there were surely many more made.

This object can be used to illustrate specific key moments in history, such as the development in the porcelain trade in China of an awareness of European markets and the increasing desirability of porcelain in the luxury goods market of Europe, but it is also important to think about trade more broadly. The development of sustained global trade networks via oceanic travel was new during the early sixteenth century and this artifact is testament to their existence. The rise of Portugal as an international power also plays a crucial part in this context. You might ask yourself, why it was that a country so relatively insignificant in more modern histories of Europe, developed into a super power during this period? Be precise in your considerations of who the actors are. It is easy to make assumptions about 'the Portuguese' or the 'Chinese', but were the people involved in the manufacture and trade of the ewer actually thinking along national lines? Were monarchs, governments or religious bodies involved and if so how? Or was innovation driven by individual entrepreneurs?

Case Study Two: Powhatan's mantle, Ashmolean Museum

FIGURE 4.4 *'Powhatan's Mantle', lithographic image of E. T. Shelton (photograph, ca. 1888); P. W. M. Trap (lithography, ca. 1888). Public Domain.*

This item is unique. It is four tanned deer hides sown together and decorated with shells. The animals depicted on the design may be a deer and a wolf. It may be a 'match-coat' or skin coat or it could also be a ceremonial cover or blanket, not designed for wearing. It was made by the Algonquian Native Americans of Virginia and came into the Ashmolean Museum in 1638 as part of the Tradescant collection, acquired when the museum opened. In 1656, in the first printed catalogue, it was listed as 'Powhatan's coat'. He was the chief of the tribe, known as the Powhatans after their chief, who lived in the region of coastal Virginia where in 1607 the English landed. He was the father of Pocahontas. The two John Tradescants, father and son, visited Virginia and may have negotiated personally with the local natives to acquire this artefact. An alternative account suggests that settler, Captain John Smith, was given the mantle among other artefacts by Powhatan and that he then willed it to the Tradescants.

The acquisition, collection and preservation of this mantle tells us a great deal about the English relationship with the Native Americans and the perception of their lifestyle in the seventeenth century. The artefact was originally collected because of its exotic 'otherness'. It represents the differences between the cultures of the Natives and the Europeans in the Americas. It was a source of interest for those who were unable to go to the United States to view such wonders.

The item also tells us about the development of the interest in collecting in this period. Following instructions by thinkers such as Francis Bacon, the Tradescants travelled Europe and North America collecting not only artefacts to illustrate the cultures with which the English were coming into contact but also the produce of the natural world: the plants, animals, birds, fish and insects. Their findings contributed to the development of early museum collections such as the cabinets of curiosities that had been found since antiquity. These collections had no overarching unifying theme other than to illustrate the variety and wonder of the natural and man-made world. Viewers were astonished by the diversity and unfamiliar nature of many of the things that they encountered in such cabinets but they may also have viewed some objects and made comparisons with things from their own lives. Just as today, museum exhibits bring us closer and distance us from the cultures whose artefacts we view. The Tradescants acquired interesting specimens for museum and for science but they were also acting on behalf of their important patrons, first Robert Cecil and then later the Duke of Buckingham. This illustrates how the patronage system of early modern England operated, as educated men without independent fortunes were able to pursue new scientific opportunities because of the support of wealthy members of the court.

But can we learn anything about the Natives of Virginia through this mantle and about their relationship with the English, who had then been their neighbours for only a generation? Because we do not understand the purpose

of the manufacture of this specific artefact, it is difficult to deduce anything from it about the rituals or daily life of the society that manufactured it. However, it is clear from its size and lavish nature that this is not an ordinary, everyday object. It is something special, perhaps, as the name suggests, made for a king or a king's chamber. The materials from which it is made give us an idea of the relationship that the manufacturers had to the natural world. They were efficient hunters of local animals and valued sea-shells for illustrative purposes. We know from other sources, both written and material, that sea-shells of several types had great significance in native culture along the east coast of what is now the United States and also in West Africa. They were used both as currency and for ritual purposes and their monetary and spiritual value is also significant as we interpret the mantle's decoration. The design also references the natural world, showing the significance of the animal kingdom to the manufacturers in both a practical and spiritual sense. That the mantle, belonging to a member of the elite, should be illustrated with either a wolf or a deer suggests that these animals were linked to strength and authority in Powhatan culture.

That such an item was traded, gifted or willed to the English settler John Smith or the Tradescants, tells us something significant about the relationship between the Natives and the English. The Powhatan tribe had no problem presenting a precious, high status, valued object to the English. The relationship between the two cultures at this period allowed for such gift or trade exchanges. Without more detailed corroborating evidence, we cannot suggest the precise reason for the mantle finding its way into English hands, so it is important not to make assumptions. How can we use such an item as this? We can make basic deductions about the culture that made it, but we can also use it to describe the relationship between the two cultures as well as the rise in collecting in England.

Case Study Three: Scotch hands, nineteenth century

Let us turn from an exceedingly rare, high status, object to something that was ubiquitous in many rural homes for centuries. Scotch hands are a piece of domestic kitchenware that were used in the butter making process. They are a pair of large wooden spatulas that were used for kneading the mixture, removing the butter from the churn and finally moulding and cutting the butter either in a shop or in a domestic setting.

The process of making butter from milk involved skimming the cream off the milk, churning it, kneading in order to distribute the salt throughout

the mixture, and then finally washing the mixture to remove the buttermilk, before working and preserving the butter. This is where the scotch hands came in. Scotch hands are also known by alternative names such as 'butter paddles'. Such common items have little intrinsic monetary value today, although they do occasionally appear for sale in antique shops where they can be bought as 'treen': antique wooden artefacts. They were low status items and are thus rarely decorated or manufactured with luxury in mind. They were purely functional. Scotch hands were manufactured from local, cheap hard wood so the material varied depending on the country of origin. Some Scotch hands from the United States are made from maple, for example; in the UK, oak or birch was often used.

It is unlikely that you will be able to find out the full 'object biography' of a pair of butter paddles that you acquire yourself from an antique shop. However, you may also encounter them in a museum or country house kitchen. What these artefacts will tell you is part of the fascinating social story of butter manufacture. These artefacts were used by women, because milking and butter making were considered women's work in Europe and in the United States. Butter making was not only a way of supplementing a diet with extra fat (a concern in the pre-diet conscious age) but also a way of supplementing the household income. Owners of a smallholding with a few livestock could sell butter to their neighbours in order to make extra money. In that way, the scotch hands are not merely tools of domestic labour but they are also tools of manufacture. This surplus may have been sold from the home, at a local store or in larger quantities in the local market town on market day. Later in the nineteenth century, butter was made in factories, known as creameries; as the process became industrialized and moved out of the domestic setting, the individual butter paddles were no longer required.

Case Study Four: Birmingham back-to-backs

How can you use the built environment as a case study in your work? One way is to use a place that has been specifically preserved because it is deemed to be of historic value. Many of the homes for which this decision has been taken are high or middle status homes, but the Birmingham back to backs, now owned by the National Trust, are an excellent example of working-class housing that has been preserved for heritage purposes.

The site has been designed by the National Trust to bring to life the day-to-day stories of the former residents of the houses on 50–54 Inge Street and 55–63 Hurst Street. Their lives is recreated in four snap shots dating from the

FIGURE 4.5 *Birmingham back-to-backs, photographed in 2010. Image shared under Creative Commons license 3.0.*

1840s to the 1970s as the curators have used sight, sound and smell to give the visitor a complete sensory experience of entering a working class home of the era in Birmingham. Volunteer guides sometimes dress up to take the part of residents in a display of living history to further evoke the given era.

So what is special about this particular site; why were these houses chosen? They are examples of an environment that was once common in Birmingham and all industrial cities but now rare. The back-to-backs have been preserved because they represent the last standing nineteenth-century court houses in Birmingham. Without their rescue as a heritage site, they may have suffered demolition, with the site being redeveloped with modern housing or businesses. The homes were built during a time of the rapid expansion of England's urban centres, but then they fell out of favour in the latter part of the twentieth century as residents were moved to more modern but fatally flawed developments, often in 'high rises' that are now blighted by social problems. The court was constructed at the turn of the nineteenth century by silversmith Joseph Wilmore. Throughout the next 150 years, working families with a variety of occupations lived in parts of the court, while other buildings within it were used as workshops. By the late 1960s the homes were unfit for habitation, but they were saved firstly by being grade II listed and then being surveyed by an archaeological unit. They were then restored by Birmingham Conservation Trust and opened during the early twenty-first century. One of the cottages on the court, 54 Inge Street, has been converted into a holiday cottage to make money for the National Trust.

An important part of the experience of the place is to know who lived there and so the exhibition names the former residents. Oral history accounts are used to tell the stories of the houses, as memories of the people who grew up there give further personal colour to the visitor experience. Visitors are not left to wander round and form their own impressions of the place but are guided as to what to feel and learn in each particular home.

This site is interesting in many ways and here are some ideas that you can incorporate into your own work. It reveals the social history of England's industrial towns over the last century and a half, and through the careful use of artefacts and re-enactment, you can get a sense of what life was really like in four snapshots of time in the houses. However, these sites can also tell you about the changing values of the heritage industry over the last few decades and show that the rise in importance of social history, history from below has influenced organizations like the National Trust in seeking to preserve and display the history. These homes tell a story that is common across the country but also try to tell unique stories about the particular individuals who lived there.

Case Study Five: Church

Another part of the built environment that provides some information about how people lived in the past is the church. This is somewhere that will be easily accessible to you (some churches may be locked, but the church warden should allow you to go in). Unlike the back-to-backs, churches do not exist solely as heritage sites, although many parishes are increasingly aware that visitors are interested in the historical context of the building and so may 'trade' on that in minor ways. However, in most cases, churches are living buildings, still functioning in their communities, albeit in very different ways from their original roles.

In many British communities, the church is the oldest surviving building. Although from a period of much lower population, it is often one of the largest buildings, built at a time when religious belief was central to people's lives. The physicality of the buildings was designed to offer praise to God, as seen through their scale, being much larger than other buildings prior to the mechanized age. The church is still often the only piece of medieval architecture that many people are familiar with and use on a regular basis. However, because they still currently function as places of worship, as well as having long and controversial histories, churches can be difficult to read. A church built in, say, 1350 is not simply an unaltered building from the mid-fourteenth century. Often churches were built on the site of an earlier religious building, so there

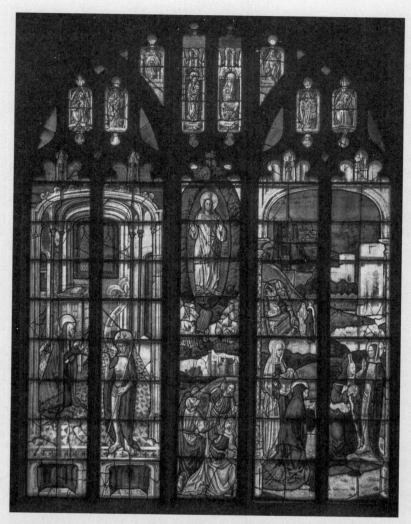

FIGURE 4.6 *St. Mary's church, Fairford, Gloucestershire. Stained glass photographed by Julian Gugoff and licensed for distribution under Creative Commons 2.0.*

may be evidence of worship there going back to early English and perhaps even pagan times. The structure itself will have been started in 1350, but it would have taken many years to complete, and the fabric of the building will have been added to from then until to the present. Internally, the look of the church will have changed many times in response to the preferences of vicars, of leading families of the parish but, most crucially, because of political and

religious changes. History is written into the physicality of a parish church, often due to what is there, but sometimes because of what is no longer there, or what has been changed over time. Churches were designed to give cues to the people who worshipped in them. The basic orientation of churches from east to west with the altar at the east end is something that we take for granted but is a good place to start when reading a building. This construction, designed to ensure that worshippers faced towards Jerusalem, tells us about the influence that the church hierarchy had on the development of rural British religious architecture.

In parish churches that are more than 500 years old, the two historical developments that help you to contextualize what you see are the Reformation and the Victorian revival. They determined the look of your parish church as you walk in to it today. Before we focus on a particular parish church, let's think about these two eras and highlight the changes that they wrought on our churches. The Reformation changed what people believed and in doing so, congregations responded by changing the look and contents of their churches. At the Reformation, the reading of the bible and teaching about it from the pulpit in the vernacular became a much more important part of religious practice. This had two effects, the altar or altars were no longer the sole focus: pulpits and lecterns were introduced. But the more important effect was that the images that had adorned church walls, rood screens and stained glass windows to educate the masses about religion were no longer necessary. Not only were they irrelevant, they were increasingly seen as idolatrous, as after the Reformation Protestants determined that such depiction of religious figures could encourage the worship of those statues and images. Stained glass was smashed, rood screens and statues were defaced, painted walls were white washed or painted over with lists of the Ten Commandments in English.

To get a sense of what our parish churches used to look like, visit a church in a Catholic area of Europe. However, many parishes are reclaiming what is left of their pre-Reformation visual heritage where possible, by uncovering wall paintings. This revival has been going on since the nineteenth century. There are two reasons for this. Congregations want to reveal the changing church over time and recover a lost era of the history of the building. More importantly, during the nineteenth century church beliefs changed again. Anglo-Catholicism influenced church design, as gothic, highly decorative churches became in vogue once more. This intellectual movement was partly driven by the yearning for a lost era but also religion became defined by the rediscovery of the aesthetic value of beautiful objects in church.

The Reformation changed the way churches looked and what people did in them. Reminders of the Catholic mass are still left in the fabric of the church, such as the piscinae for priests to wash their hands before mass or the squint to allow congregations worshipping at side chapels to see the elevation of the host, which was a key point during the Eucharist. The purpose

of particular areas in the church also changed. Porches had a much greater spiritual significance in the early modern period as liminal* spaces, which play a key part in, for example, the now defunct churching ceremony which was used to welcome a mother back into the congregation after she has given birth. Porches were also used as classrooms in the period before formal school buildings were constructed and may also have been home to those claiming sanctuary.

Let us now look at a particular example of how we can use the built environment of a church, St Mary's, Fairford in Gloucestershire. Although a priest is recorded on the site in the Domesday Book, the existing church was built relatively late in the medieval period, dating mostly from the late fifteenth century. It is a 'wool church' built because it was built with the patronage of the extremely wealthy wool merchants in the Cotswold region. John Tame funded the reconstruction of Fairford Church in 1490, and he was buried there in 1500. Wool churches were large and grand, built in the latest fashionable style because they were there both to celebrate the glory of God and the wealth of their patrons. Wool areas did not employ large numbers of people, so large churches such as this would not have often been full.

The perpendicular style of architecture allowed a great deal of light to enter the church, and so its glory was in its windows. They were manufactured by Richard Flower, an immigrant glazier from the Low Countries, who also worked as the King's glazier in Westminster. Barely a generation later, the Reformation changed the design of the church but unusually, did not destroy Fairford's windows. A key question to ask is how and why were they protected? They are very special, but it would have taken an influential local patron to prevent their destruction. Over the ensuing centuries storms and wear have threatened the stained glass, but it was formally conserved at the end of the twentieth century.

The glass consists of twenty-eight windows, all telling bible stories. Old Testament stories such as Adam and Eve and the Judgement of Solomon sit alongside the life, death and resurrection of Christ, the stories of his apostles and the lives of some church fathers. An especially vivid window tells the story of the day of Judgement with striking depictions of Satan and his demons. As well as vividly depicting these stories for the illiterate population unable to read the Bible in Latin, the windows also represent well-known people from the time of their manufacture, especially royalty. It is possible that Henry VII gifted the glass to Fairford after he had claimed lands in the area from a traitor whom he had executed, but there is no documentary evidence to prove this assertion.

*Definition: a place on the boundary or threshold.

As well as the existing church being protected at the Reformation, it also acquired new furnishings. The choir stalls and misericords date from around 1300 and probably came from Cirencester Abbey at the Dissolution of the Monasteries. This shows both opportunistic behaviour by church wardens wanting to enhance their own church but also reflects their commitment to the saving of the beauty of the Catholic church. Misericords (the name taken from the Latin word for 'mercy') are stools on which the choir and priests might perch while listening to long bible readings. It appeared that they were still standing but they could take the weight off their feet. These are present in many churches and cathedrals and are interesting in design because they are often illustrated with carvings that reveal secular themes such as local figures, real or mythical animals or humorous sketches of strife in the period, such as the Fairford misericord which shows a woman beating a man. These had a dual purpose: to entertain and also to provide a moral message, in this case, that just as God ruled over his church, it was important for a man to rule firmly but kindly over his household to maintain the natural order.

In many ways, this is a very special church. It is special now, because, as well as having the best stained glass in the country, it has evidence of wall paintings and early Tudor carvings. Fairford is unusual in the extent of these survivals. It was obviously wealthy, well-endowed and with a possible royal connection. However, it can also be thought of as typical. Many churches had riches similar to this that were deliberately destroyed, lost or sold over the centuries. Fairford is an excellent example to study if you are thinking about who and what influenced the appearance of a parish church. We know the names of benefactors and craftsmen here, whereas in many cases these remain anonymous. However, Fairford still presents us with many unanswered questions, especially regarding the issue of why so much of the fabric of the church was preserved here and not in the vast majority of others.

Case Study Six: Your own home

Finally, your research into the built environment and its historical context can be started without leaving your own home. Perhaps if you are living in modern halls of residence on a university campus built in the last few decades, this case study will be less relevant, but for most people, their home has been the site of important historical events. In terms of the life story of individuals, a house more than a few years old will have seen births, marriages and deaths within it. If your home is over 100 years old and in the UK, you will be able to

access census records to learn the names of the people who lived there in the past. Their histories can be told through their interaction with the house. You may get a surprise when you find how many people once called your dwelling 'home'; a large family easily occupied what we now consider a small starter home.

The home itself can be studied as a piece of domestic architecture. What date was it built? What type of housing: elite, working or poor? The story of its construction can be told by relating it to architectural trends but also to the development of the city, town or village where it is sited. Particular streets and regions of a settlement were developed with domestic housing in response to demographic developments, such as an influx of workers. So, why was your home built? Who paid for and built your house and those in the neighbourhood? In the late nineteenth and early twentieth centuries, building firms with a strongly non-conformist ethos often refused to include public houses and taverns in the streets that they developed. In some cases, this lack of pubs persists to this day.

The interior plans of the home can be related to those of similar dwellings, telling us about the everyday living experiences of those residing there. At what point was plumbing or electricity added, for example? The changing function of an outside toilet building shows how people's everyday lives drastically altered, an aspect of life rarely discussed in other types of sources. Your home may not always have been a home. It may also have served as a shop, a pub or workshop. Is there any evidence of this, perhaps in the positioning of doors and windows or of chimneys? Can you corroborate this with textual evidence, perhaps through local trade directories? Examining the function of each room is crucial too. The nature of the bedroom has changed over time. Often, it was not a private space but a shared space. In your house, was a parlour or front room kept for 'best', for visitors or perhaps even for laying out the dead? You will not be able to find answers to all of these questions simply by looking round your house, but in conjunction with other sources you learn how your house can itself be a primary source.

The home can also be studied in relation to other dwellings and buildings in the neighbourhood. For example, perhaps you live in workers' cottages, built by a philanthropic mill owner or farmer. The proximity of these cottages to the place of work would have once been crucial, even if the factory or mill no longer exists. Perhaps your home was built to house workers in a particular industry that was done domestically, such as dyeing which required the presence of running water or crafts requiring light and well-lit 'top shops' or top stories of the building. Your home could contribute to your understanding of the industrial development of the region and of the economic development of the country. The relationship of buildings to the natural environment can be determined by looking at maps of your local settlement. You will get a

sense of how your village, town or city changed over time and you may be able to assess why it was built in that particular location. As you can see, your home can tell you a great deal about two aspects of the past: the economic, demographic and political development of the settlement where you live and its relationship to developments on a national and international scale, as well as the everyday domestic lives of the people who have lived in your home since its construction.

CHAPTER FIVE

Practical Applications

Throughout this book you have learned theoretical and methodological guidance about how you might use non-textual sources in your study of history. At the end of each chapter, case study examples have illustrated how the theory might be applied in a concrete way. In this chapter, we will sum up the most important points about each source type and also look at ways of integrating this sort of analysis into your work. Crucially, we will also think about some of the practical ramifications of using visual material in essays, presentations and other assignments.

Summary of what you have learned

This book has tried to steer you away from the danger of using non-textual material as a supplementary aid, as mere illustration, designed to evoke a certain period-feel, while offering no analysis as to the historical significance of the image, thing or place. If you take away one key message, then it should be to avoid this unthinking use of non-textual material as solely supplementary. It must be afforded the same treatment and respect that you would give to textual primary sources. The second important message to remember is that the non-textual and the textual should not be artificially separated but, rather, the examination of one should complement the other. Taken together, they can reinforce your understanding, but beware of assuming that a single uncomplicated message will emerge. Be alert to the diversity and complexity of the historical significance of all types of source that you study. Things are not always what they seem!

First we examined what we might learn from other disciplines that already have non-textual sources at their heart. From art history, we understand that

commercial and aesthetic value plays a significant part in our understanding and assessment of images. Since the Renaissance, the role of the supposedly single creator of a piece of art has been emphasized. Although we know that sometimes this attachment of a single name to an artefact is false, it helps us to put the piece of work into the artist's career trajectory. It makes us think about the relative significance of the role of an individual in creating the image or whether the cultural and intellectual *milieu* of the time had an influence. Finally art history is a vital source of information on the iconography of images, helping untrained historians to interpret the meaning of particular colours or representations.

Film studies is also a useful discipline because it gives historians the framework within which to analyse the output of the movie industry. We learn how to study the history of the industry itself and to see a particular movie as part of a genre or a director's *oeuvre*. Archaeology guides us as to how to periodize and categorize material culture by precisely defining the artefact itself and by noting the place where it was found. Architecture shows us that buildings are not merely utilitarian and reflections of economic developments but that aesthetics of building design and the proximity to sources of local building materials have an important influence in the evolution of our built environment.

In Chapter Two, we looked at the reasons for incorporating different types of image into our work. We studied painting, photographs, maps and cartoons. Of vital importance is to develop an understanding of the reason behind the creation of an image, whether a portrait of a monarch or an advertising billboard. The structures of authority that lie behind the creation of many images are significant because we need to understand who is controlling the message. Often, it is not the creator but some other force such as the state. The role of the audience was also addressed, both in the sense of the contemporary audience, often appreciated and targeted by the creator but also historians as an audience. It is important that we are self-reflective and understand how and why we view, interpreting the preconceptions and prejudices that colour our reception of particular images.

Chapter Three examined a range of visual and audio recordings. We began by thinking about how the theories of film studies can help historians to interpret them. Film studies provides guidance on the way that genre manipulates meaning and also how examining the works of a particular director can shape our understanding of the significance of a film. However, historians must always come back to the question of the historical and technical context of a film's creation. Examining contemporary audience responses to the film also helps historians to interpret it. Non-fiction productions are another challenge, and it is easy for the historian to fall into the trap of assuming that documentaries and news reports tell realistic stories about the past, but this is not always the case. They must be analysed critically because they also have an agenda. With these types of

media, and with radio broadcasts too, it can be difficult to work out whose message is being conveyed, is it the owner of the medium, the producer or director of a particular show, the journalists or researchers who have created the material or the presenters or actors who present the material to the public? Chapter Three also examined the source material produced when undertaking oral history interviews. The historian can either make use of interviews recorded by someone else, in which case it is important to understand the limitations of the interviewer's vision and the factors that manipulate the interviewee's responses. Or the history student can undertake his or her own interviews, in which case it is vital to establish the conditions which allow the interviewee, as far as possible, the freedom to respond honestly and carefully while being guided towards the most fruitful avenues to explore.

Chapter Four discussed the use of two tangible types of sources, firstly material culture (things) and secondly the built environment (places). They require grasping a new methodology and a new way of imagining the past. We must understand the significance of material culture itself, but we are also required to interpret its being preserved and collected if found within a museum. We must question the survival of things; when many things from the past no longer exist why is it that this particular artefact has survived? Is it because it is very special or because it is very common? Using the built environment as a source requires us to open our eyes and begin to look at the world around us as a historian. The familiar must become strange to us as we no longer take our surroundings for granted. Personal stories of individual lives can be illuminated by exploring the local history. Alternatively a big-picture approach can reveal the economic, political and social upheavals that influenced the creation of a particular building, or a whole street or settlement.

Now that we understand the key challenges faced when interpreting non-textual sources, let us move on to think about the practicalities of finding and using such material. As a student with an assignment due in a few weeks, in what ways can you start to practically engage with this source material?

Finding non-textual sources

In order to use non-textual sources in your written work, you need to first locate them. Be aware that if you make detailed use of them, it is necessary to have copies of them to insert into your essay or dissertation. It will not simply be enough to describe these items, images of them must be placed in the body of your work or in a separate appendix so that those marking can see how and why you have used them. So, how do you locate such sources and what are some of the problems encountered when using them?

The best way for a historian to begin to locate primary sources of any type is to make use of the internet. If you are able to travel to visit archives, you can plan your research trip in advance by using online catalogues and calling up information ahead of time to prevent having a wasted journey. However, digitized materials are also commonly available, especially for the histories of Britain, Europe and the United States where universities, libraries and archives have the most money to invest in such digitization projects. Availability of this type of material has revolutionized the ways that academics do research. However, students seem less confident in using such material. They are right to be wary, in many cases, but there is also some valuable digitized material online, easily available to use as source material for essays.

This availability of online resources presents the scholar with a methodological dilemma. Are you happy to view the item you wish to study online? It can give you a sense of the look of the source, but until you encounter the real thing you don't have any understanding of its materiality. Sometimes digitized images are of poor quality because of being low resolution and so viewing particular details is challenging. Also, the choices made by those digitizing the material must be considered. If every item in a collection has not been reproduced in this way, why not? What does this tell us about the choices made by curators and librarians? Why have they prioritized particular images over others?

Another issue with accessing sources of all types (including textual ones) is the matter of reliability. Is an image exactly what it claims to be? It is important to use reputable web pages to source your non-textual resources. If you find an image that would be very useful, but one that is being used for illustration on a blog or other unverified website, with little information about the image's origin and provenance then do not use it in your work. Unreliable sources might highlight to you a really useful image for your project, but it is up to you to then investigate further to find out where that image originally comes from. Only use sources whose precise history can be traced, whether it is their original place of publication if appearing in printed matter or their archival record if manuscript. Sometimes material is placed online with little attempt to organize or catalogue it. Again, use this as a starting point, but only refer to material about which you feel confident that you can detail its origin. It is important to think about the intended audience of online material. Sometimes scholars are not the intended audience and so the information is not presented in a conducive way to developing your research. It is your responsibility to ensure that the evidence you present in your essay is reliable and accurate.

When using images taken from online sources remember how easy it is to digitally manipulate images. Make sure that the images you are using are verifiable as historically accurate, that is, they are what they

purport to be. In the twenty-first century, we are surrounded by images, and we have come to define our own life story through the selfies and other photos that we post of ourselves online. You know how easy it is to amend a photo by cropping it or otherwise altering it. Always be aware of the possibility that someone else has done the same thing to an image that you hope to use. Perhaps the very fact that an image has been altered is what interests you, for example, in the case of the censorship of photos of Stalin's former allies in communist Russia. As long as you critically analyse the reasons for the manipulation, this can become part of the story you tell about the image.

Sourcing film, music and other audio documents online can be challenging for a similar reason. How do you verify their authenticity? When finding films, resources such as YouTube are invaluable, but remember that anyone can make a film at any time on any topic. Something purporting to be an old television advertisement, for example, might be a cleverly created modern parody. Before making use of such resources, you need to do as much research as possible to verify that what you are looking at is what it claims to be. Is there evidence of its existence on other corroborating websites? It is possible to source non-digital versions of film, music and radio, for example, on older media such as cassette or video tapes. You must consult your tutor and discuss with him or her how you might present such evidence. Markers will want to examine it alongside your essay but, later on, an external examiner may need to look at it too. Another problem with using online resources is their lack of permanence, especially regarding, for example, film clips on YouTube. Therefore, where possible download or copy to your hard drive the sources that you want to use. Make a note of the date on which you did this, as it will form part of the reference when you record in your footnotes where you found this item.

One of the most difficult types of non-textual source to find is the 'thing', the artefact of material culture. As a scholar you need to make a decision whether you want to locate and observe the artefact yourself, perhaps even handling it if that were possible, or whether seeing a picture of it will satisfy your purposes. If this item is going to form only a small, tangential part of your argument, I would suggest that accessing the item via an image will suffice, and in which case, the best place to find pieces of material culture is on museum or gallery online catalogues. These catalogues have the advantage of giving detailed information about the provenance of the artefact, a precise description of it and these websites will also have one or more images of the item.

However, if you feel that in order to analyse this artefact properly you want to see it in person, then you have two choices, depending on the nature of the artefact. It is possible to visit museums and galleries and to make an appointment with a curator who will guide you to the item and may let you

examine it. He or she will also be able to give you contextual knowledge about the history of the item since it has come into the museum, and they will direct you to any published research that has been done about it.

Another alternative is to acquire the artefact at auction. Online auction sites make this sort of purchase very easy. Of course, this will not be possible if the item that you hope to make use of is incredibly rare or expensive, but you may be surprised how cheaply old artefacts can be acquired. For example, nineteenth-century Scotch paddles like those mentioned in Chapter Four's case studies are available to purchase online for under £50. This cost may be prohibitive to you, but if not, and if this item will form a central part of an argument in an important piece of work such as a dissertation, then you may consider the purchase worthwhile. Of course, as with all activity online, be careful when making a purchase to ensure that the item exists precisely as described and is not a modern replica. Another advantage of owning such an item yourself is that you can take photographs of it to accompany your piece of coursework and you will face no copyright issues because you own the item.

Copyright

It is important to be aware of the restrictions placed on your use of other people's images, film and audio recordings by copyright law. Jenny Presnell offers detailed advice about how students can avoid falling into difficulties with copyright law when using these types of sources.[1] The basic rule of thumb is that if you are using an image or film or audio clip in a piece of coursework that will be seen only by you, your tutor and an external examiner, then you are permitted to do that, provided you fully acknowledge its origin. This is the case whether the item is an online resource or an archival one. This is another important reason for making sure that you have traced the image to a reliable source. However, if the piece of work for which you are preparing is an MA or PhD thesis, because these are made publicly available for others to view, you must be more careful and seek copyright permissions from the owners of copyright of the sources that you will use. Similarly if you are producing an assignment that will be viewed by members of the wider public, such as an open access website, then you must ensure that the images you use are either copyright-free or, again, you need to get permission from the owner. It is unlikely at undergraduate level that you will be publishing your research findings, but say, for example, that they will be published in a student journal or newspaper then, again, you need to acquire copyright permission.

Copyright-free images are useful for illustrative purposes, but they are very limited if you require a particular image. There are many websites dedicated to copyright-free images and so you will easily be able to find

something to illustrate your piece of work. However, the message of this book has been to encourage you to use images as more than mere illustration and to focus on analysing a particular image and making it integral to your argument. Therefore the limited nature of copyright-free images means they are inappropriate for most essays.

If you have used a non-textual source in a library or archive, you may be allowed to take a photograph of the item for your own use. In some cases there will be a charge for this service. You will have to sign an agreement that you will not publish the image for commercial gain. In many cases, copyright holders will grant permission for limited use of an image, either electronically or in a written piece of work, simply in return for an acknowledgement that the source is theirs. This is usually the case with academic libraries and archives. They realize that you will not be making money through the publication of their image and will permit you to use it in one particular instance. You will have to sign a contract guaranteeing that you will not use it for any other purpose than that. You may have to pay a fee to acquire a high-resolution version of the image. However, some copyright owners do insist on payment, and in some cases this can be very costly – as much as several hundred pounds per image. This is especially the case if you wish to use a particular image several times, such as, for example, of the front cover of a book. Undergraduates will rarely require this but it is important to be aware how copyright works. The precise legal definition of the rights of the copyright holder varies from country to country but, for your purposes, it is better to be confident that you are not contravening the law by contacting the copyright holder and asking for permission.

Practical applications

In the section above, I have assumed that the project you are undertaking is an essay or dissertation. Many history assignments do indeed come in this format and therefore it is a good place to start. However, I will also show how other types of assignment can be enhanced by engagement with non-textual sources.

The essay, usually between 1,500 and 8,000 words and the history dissertation, of around 12,000 words are standard forms of assessing students' understanding of the discipline at university level. They involve an argumentative question, pre-set either by the tutor or by the student themselves, that will be answered usually with reference to both secondary and primary literature. The student should show that he or she is familiar with current debates surrounding the question but also should also present his or her own argument and allow his or her research and findings to come to the fore. Essays and dissertations are where you develop your 'voice' as a historian.

There are two basic approaches to the argumentation in an essay. The first one involves *a priori* assumptions: the student knows what he or she wishes to argue and finds the evidence from the work of other scholars and from primary sources to prove this case. This often produces strong, well-argued essays but can also lead to challenges about the validity of the student's historical method. After all, in this model, his or her opinion would have remained fixed no matter what evidence was discovered. Perhaps the evidence presented has been chosen to support the argument rather than because it represents the variety of ideas encountered. To an extent all historians do this; it is difficult to avoid coming to the material with preconceived ideas, even subtle, almost subconscious ones. These ideas will be personal, derived from one's own experience of education and of current affairs but will also be influenced by one's peer group and family opinions. The second approach, which is probably more common in undergraduate students, is that the student has a strong interest in a particular area, but begins with no real sense of his or her opinion when answering the question. He or she prefers to be guided by the literature, deciding later, nearer the end of the process, what the answer to the question will be.

In both cases, as this book has shown, evidence gathering can and should include non-textual material. In most assignments, non-textual evidence will be considered alongside more traditional historical sources, although in some cases it will be possible to prioritize and perhaps even solely consider non-textual material. For some subject areas, non-textual material can actually enhance the primary source use. For example, if you are writing a history essay about a country whose language you do not speak, it will be challenging for you to access primary source material unless you are able to get translations of such material. However, by accessing visual material you can avoid the problem altogether, as long as you educate yourself about the conventions of the creation and distribution of that source. Perhaps you might only need to have a few words translated, as in the case of a cartoon caption. Using non-textual sources are also an excellent way of accessing topics for which written primary sources is also rare, for example, when writing about illiterate or semi-literate cultures.

Using such sources also allows you to tap into the 'cultural turn' and to show that you are aware of this historiographical development. In the last couple of decades, responding to post-modern theory and especially semiotics, scholars have become more interested in the history of mentalities in the past – of representations and perceptions. Of course, history is still about what has actually happened in the past but also, increasingly in recent years, about what people thought and felt in the past. Visual and oral testimony is an excellent way of accessing this. By foregrounding non-textual material in your essay or dissertation, you are thus showing that you understand this subtle change in historical practice and are responding to it yourself.

Other types of assignment

Increasingly, universities are asking their students to do a wider range of coursework assignments. The reason for this is that experience gained allows students to develop many different skills, which they can take forward into their future careers. Undertaking a variety of assignment types allows students who learn in different ways to display their knowledge and understanding. Some students prefer extended writing and exams, whereas others feel that different assignment types allow them to better display their knowledge. I will discuss three alternative types of assignment below that encourage the use of non-textual resources and allow you to fully develop your skills in this area. In many ways these non-traditional assignment types are even more suited to non-textual sources.

Many students are required to do a piece of primary source analysis at the beginning of their degree programme. If you are able to choose your own primary source, why not select something non-textual? This piece of work is often shorter than a typical essay but still requires you to display analytical skills and depth of research. You may have had some experience of this sort of exercise before, as many secondary school history exams at GCSE level include an element in which the candidate discusses the significance of an image. Although not in every case, this exercise is usually dropped at A level, but you now have a chance to revisit your image-analysis skills at university. Choosing a piece of art, a cartoon, a photo, a song, a radio or television broadcast, a film, a place or a piece of material culture shows your tutor that you think more broadly about the discipline of history and that you are willing to engage with the latest trends in the discipline. In a primary source analysis, you will be asked to discuss questions such as defining the source by genre, creator and audience, place and date of creation. You will also be asked to think about the meaning of the source, what it says about the historical context and what messages it is giving. Finally, you will usually also have to discuss some of the challenges and problems that using this type of source poses to the historian. Hopefully this book has given you the skills that you need to do just that.

Another form of assessment increasingly favoured by history lecturers is the oral presentation. This can take various forms but is undertaken either by individuals or groups, in front of other members of the cohort or, since the advent of cheap digital cameras, the presentation might take the form of a video recording. Because a presentation is itself a visual medium, non-textual sources work especially well. Think about the sort of presentation you see every day at university: the history lecture. Many lecturers make extensive use of visual, film and audio sources in their lectures to great effect. Of course, some simply present this as 'filler'; something for students to look at to keep them entertained while the lecturer is talking, but the best lecturers build their argument around key sources and use them as integral

parts of their talks. Another example of bad practice that you can learn from is the presentation that has been stymied by technical issues. This could be the choice of an image that is so small or blurred that it is impossible to see any detail on it. Or it could be a film or audio clip that fails to work due to incompatibility with the computer system. Such frustrations mar the enjoyment of a lecture and could just as negatively impact on your own presentation, so make sure that if you do choose to use visual, audio or film material, that it is accessible to your audience. Another way of being innovative during presentations is to use artefacts. These can be excellent tools for engaging your audience and also for illustrating complex historical points.

Presentations ask you to do many things, but a vital point is to think not only about the material itself, the historical content and the research that you are presenting but also about the medium, about how you present that material. You will be marked on your speaking style, on pace, volume and on eye contact. You will have to show that you have considered the needs of your audience and have varied your presentation accordingly. The best presentations do not simply read out a pre-prepared script but there is an element of awareness of the importance of performance. Having visual props in the form of a PowerPoint presentation, or actual material evidence, can serve to show that you have considered the best ways to present your information in an educational and entertaining manner. These aids can also give you some much needed reassurance. It can be lonely standing in front of a classroom or a camera in order to give a presentation, even if just for a few minutes. Doing a 'show and tell' by discussing a particular image, film or audio resource acts as a prop and gives you confidence.

The third type of assignment, in which you might use non-textual resources is an unusual one, but one that will be used increasingly as concerns over employability of students are heightened (I'll discuss employability in more detail in the postscript). This is an assignment that I have created for use in a second year history module entitled 'Slavery in a Global Context'. I ask my students to plan their own museum exhibition. They have to collect electronic images of pictures, things and documents from their period and place of study and they have to arrange them in a PDF document alongside captions explaining the significance, as if these pictures, things and documents were being displayed in a museum exhibition. Students have to consider the audience, who are members of the general public, and their level of knowledge. This is also accompanied by an essay that acts as the introduction to the exhibition catalogue, highlighting the rationale behind the 'exhibition' and presenting the historical context just as a real exhibition catalogue would do.

As you can see, in this type of assignment the non-textual elements take centre stage, because you have to consider their historical significance and the message that presenting them in a museum, to members of the public, would convey about the past. Undertaking this assignment shows that

you have a thorough understanding of the topic because you need this deep comprehension in order to convey its essence to others. This type of assignment calls for creativity as well as analysis and so appeals to students using a range of different learning styles. As more history departments realize the importance of teaching with material culture, such assignments will become more common.

Of course, when undertaking any of these assignments, it is crucial to discuss your ideas with your tutor or supervisor. He or she will be marking the piece of work, so if you attempt something unusual or innovative, such as using a type of source not previously suggested in the course literature, then before you complete the work and hand it in, check that this will meet the requirements of the marker. This book, if it has done its job, has enthused you to use a wider range of source evidence, but you still must ensure that your approach is valid and relevant for your particular piece of work. A tutor will question the use of non-textual sources if he or she thinks they are being used in a purely descriptive, basic way (for example, if you have asserted that this twenty-first-century movie shows what happened in the past) rather than in an analytical, critical way (asserting that this twenty-first-century movie shows what we think happened in the past and the creative choices made by its creators tell us something about the key controversies in the field). Your tutor will want to know that you have the skills to properly interpret the source concerned, and by making use of this book, you can reassure him or her that you understand the demands of using such sources in historical work.

I hope that this book has also given you the confidence to begin to select your own source material for use in assignments. The case studies at the end of each chapter give you a flavour of the sort of material that might be relevant in a range of cases. First it is important that you understand how to use these sources if they are presented to you. But second, I want you to go out and find these resources for yourself. The internet has revolutionized possibilities in this area, and you can now make practical use of non-textual sources in a way that was never possible only a few decades ago. Selecting relevant sources is never easy. In the first year of undergraduate education, students should be trained in how to create a bibliography, a list of textual resources available on a particular topic. Similar methods apply when using non-textual material. First compile a detailed list of sources you think contribute to helping you answer your question. Then spend time carefully and methodically viewing or listening to those sources, taking detailed notes about the passages relevant to your work. Research the historical context and provenance of those sources that are useful, so that you fully understand their nature. Then locate any supporting textual material that helps you to interpret the sources. And finally consider locating copies of the images and links to include in your written work or presentation at the point at which you discuss them.

By choosing to read this book, I am sure that you are already a lover of history, a genuine enthusiast. Making the choice to broaden the scope of primary source evidence that you engage with during your time as a history student will only serve to enhance this enthusiasm. It allows you to develop new skills and learn new things about the way different types of media work. You can explore different disciplines and learn about the ways that art or film historians, for example, see the world and you can borrow their best methods and theories. But primarily, you will gain a new perspective on the stories that we tell about the past. Metaphorically speaking, non-textual sources help you to see the past in glorious 'Technicolor', by highlighting topics and approaches that have been hitherto inaccessible. You know that using these sources can be problematic, but also that they can give you a connection to the past that is simply unachievable by words on a page.

Postscript

As well as enhancing your understanding and enjoyment of the discipline of history, engaging with non-textual sources can have a long-term impact on your career development. Increasingly, universities are concerned with their students' employability: their potential to secure an excellent job at the end of their degree. Even as a new student, on the first year of your degree programme, it is vital to consider your life beyond university so that you are able to compete in a challenging job market. You might think that little of what you learn during your history degree will have an impact on your career unless you become an academic, especially something as esoteric as the study of non-textual primary sources. However, this is not the case. The skills that you acquire undertaking the sorts of analysis described in this book will be useful to you in developing your future in the world of work and this section will show you how.

You have probably heard a great deal of discussion about 'transferable' skills. It is a buzzword within the higher education sector that has been a concern of academics for some time now. We know that most of our students will not go on to pursue their study of history in great depth in their future career. It will become only a hobby for all but a very few. So why are you doing history at university? This is not the place for a philosophical discussion about the importance of a humanities education. But what I will say is that part of the reason that you are undertaking higher education is to prove to graduate-level employers that you are capable and proficient in certain areas. An obvious example often given is that by undertaking a group project in your university degree, you can display to future employers that you are a good team player, used to cooperating in extended group discussions with your peers. Many of these skills, such as team work, time management and independent research

are invaluable in a wide range of careers, and are especially honed in undertaking the rigours of a history degree. So, where do the non-textual sources come in?

As discussed above, being able to select, manipulate and present images in the form of an oral presentation is an important skill that you will develop at university. Many roles require you to undertake presentations, both at interview, and once you are actually employed in the job, and through your understanding of the significance of images, you will know that putting together such visual material is not to be undertaken lightly. It is crucial in enhancing the content of your presentation and will not serve as background filler to entertain an audience. But more relevant are your analytical and critical skills. Yes, of course you are unlikely to work in an environment that requires you to analyse a historical image for its own sake, but in any field where you are required to present visual material, either in print or digitized, you will be ahead of your competitors because you have the skills required to interpret and select material successfully. Crucially, you have the theoretical background to understand how the choice of image can affect the understanding and emotion of an audience. You have learned some of the theories of audience response that explain how the viewer imbues an image with meaning. You know how careful you have to be in presenting this material in order to guide and influence your viewer in the direction that you want. You also understand how it is possible to manipulate images by the context in which they are presented, by physically altering them or by using accompanying textual material such as captions. You also understand how the creation of images, film or audio is not the result of the work and ideas of a single author-creator but the output of many individuals.

There are two types of career that lend themselves specifically to the sorts of skills listed above. First, those traditionally linked with a history degree such as museum and archive work or teaching. In these roles, you are essential a historian outside academia. Experience with non-textual sources can put you ahead of the competition in regards to applying for museum or gallery work because you understand the significance behind the decision to collect, interpret and present images and material culture to the general public. You have interacted with museums and galleries not only as a member of the public, but also by working with material culture in your essays, you have imagined yourself in the role of curator, determining the significance and meaning behind individual artefacts and broader collections. Similarly for archival work, much of the material an archivist handles will be textual, but being able to display a skill with non-textual sources could set you apart from other candidates. Archives may variously contain photographs, maps, charts as well as written sources, and being aware of the importance of precisely cataloguing and interpreting such sources is an important skill to develop.

Many students with history degrees go on to become schoolteachers. Experience with visual material is something that will allow you to create entertaining and informative lessons for your pupils. In many schools, visual material and artefacts are used successfully to engage students who may find textual material more challenging. This ensures that students with diverse learning needs are catered for. In some schools the use of visual material, especially film and documentary, has been relied upon by extremely busy teachers, who have not been well prepared, as 'filler' to take up time in the classroom. Using visual sources in such a way is as demoralizing as simply reading from a textbook every lesson. This book has shown you the importance of active engagement with the sources that you use, and now you can encourage the same thing in your students. This may become part of your teaching philosophy. Allowing school children to experience the excitement of working with non-textual material and alerting older pupils to the challenge of not simply taking such material at face value is something that is a mark of a good teacher. Such experience can be described in applications for teaching qualifications and for jobs themselves, and also during interviews.

The second type of career that can make use of such skills is that which involves the presentation of visual material for purposes of education or persuasion. Many careers have an aspect of this included in their job description, but some are more focused in this area than others. For example, journalism, whether newspaper, magazine or online, is one such role in which a proper understanding of how to analyse and use the visual, plays a crucial part. The skills that you have learned undertaking a history degree will allow you to select visual evidence in support of your journalistic arguments just as you did in preparing essays and dissertations. You understand how presenting an image in a certain way creates meaning, but also how it is possible to manipulate an image. You may be involved in contributing to the creation of images yourself, guiding a photographer or cameraman, knowing how you can influence the construction of that image in order to influence the hearts and minds of the audience for which it is intended.

Advertising and marketing are two other industries in which having the skills of image manipulation and an understanding of the theories of creation of meaning and audience response is crucial. In these fields, you will be asked to deliberately present material in order to sell a product or service. Your assignments for a history degree may seem a long way from such commercial output as advertising, but the skills that you employ are the same and a potential employer will admire your lateral thinking in connecting the two disciplines.

Of course when applying for the jobs mentioned above, it is vital that you also display the more traditional transferable skills such as communication, creativity, IT skills and teamwork. But one thing that interview panels appreciate is a concrete illustration that you have a

particular skill. It is not sufficient to claim that you have a skill without illustrating a case in which you used it. This is where your history assignments come in, providing excellent case studies with which to demonstrate your abilities. Engaging with visual and audio material, and places and artefacts will hopefully help you to get a good history degree, and could enhance your job prospects too.

NOTES

Introduction

1 Peter Burke, *Eyewitness: The Use of Images* (Ithaca, NY: Cornell University Press, 2001), p. 10.
2 Michael Ann Holly, *Past Looking: Historical Imagination and the Rhetoric of the Image* (Ithaca, NY: Cornell University Press, 1996), pp. 26–27.
3 Ludmilla Jordanova, *The Look of the Past* (Cambridge: Cambridge University Press, 2012), p. 4.
4 Derek Sayer, 'Photographs', in Sarah Barber and Corinna Peniston-Bird, eds., *History Beyond the Text* (Abingdon: Routledge, 2009), p. 58.
5 Jordanova, *The Look of the Past*, p. 121.
6 Holly, *Past Looking*, p. 2.
7 John O'Connor, *Image as Artifact: Historical Analysis of Film and TV* (Malabar, FL: Robert E. Krieger Publishing Company Inc., 1990), p. 294.

Chapter One

1 David Freedburg, *The Power of Images: Studies in the History and Theory of Response* (Chicago, IL: University of Chicago Press, 1989), p. xx.
2 Ludmilla Jordanova, *The Look of the Past* (Cambridge: Cambridge University Press, 2012), p. 213.
3 Ibid., pp. 60–61.
4 Sarah Barber, 'Fine Art', in Sarah Barber and Corinna Peniston-Bird, eds., *History Beyond the Text* (Abingdon: Routledge, 2009), p. 27.
5 Janet Staiger, 'This Moving Image I have before Me', in John E. O'Connor, ed., *Image as Artifact: Historical Analysis of Film and TV* (Malabar, FL: Robert E. Krieger Publishing Company Inc., 1990), p. 267.
6 Jordanova, *The Look of the Past*, p. 20.
7 Jonathan Culler, *The Pursuit of Signs: Semiotics, Literature, Deconstruction* (Abingdon: Routledge, 1981).

Chapter Two

1 John Tagg, *The Burden of Representation: Essays on Photographies and Histories* (London: Macmillan, 1988), p. 56.
2 Ludmilla Jordanova, *The Look of the Past* (Cambridge: Cambridge University Press, 2012), p. 164.

3 David Freedburg, *The Power of Images: Studies in the History and Theory of Response* (Chicago, IL: University of Chicago Press, 1989), pp. 2, 6.
4 Frank Palmeri, 'The Cartoon', in Sarah Barber and Corinna Peniston-Bird, eds., *History Beyond the Text* (Abingdon: Routledge, 2009), p. 36.
5 Peter Burke, *Eyewitnessing: The Use of Images as Historical Evidence* (Ithaca, NY: Cornell University Press, 2001), p. 30.
6 Tagg, *The Burden of Representation*, p. 64.
7 *Popular Photography*, February 1960.
8 Available at: http://web.archive.org/web/20020602103656/http://www.newtimes-slo.com/archives/cov_stories_2002/cov_01172002.html#top

Chapter Three

1 Janet Staiger, 'This Moving Image I Have Before Me', in John O'Connor, ed., *Image as Artifact: Historical Analysis of Film and TV* (Malabar, FL: Robert E. Krieger Publishing Company Inc., 1990), p. 267.
2 Thomas Cripps, 'Stalking the Paper Trail', in O'Connor, ed., *Image as Artifact*, p. 138.
3 Later and even more controversially, he also wrote arguing that realism in film and its ability to depict 'reality' was its greatest asset.
4 For more on the visual language of film for historians, see O'Connor's *Image as Artifact*, pp. 302–321.
5 Jeffrey Richards, 'Film and TV', in Sarah Barber and Corinna Peniston-Bird, eds., *History Beyond the Text* (Abingdon: Routledge, 2009), p. 72.
6 See http://bufvc.ac.uk/newsonscreen/learnmore/texts
7 Alex Beam, 'The Prize Fight Over Alex Haley's Tangled "Roots"', *Boston Globe*, 30 October 1998.
8 Jan Vansina, *Oral Tradition as History* (London: University of Wisconsin Press, 1985), pp. 98–101.
9 C. Peniston-Bird, 'Oral History' in Barber and Peniston-Bird, eds., *History Beyond the Text*, p. 106.
10 For more on this see Trevor Lummis, *Listening to History* (London: Barnes & Noble, 1987), pp. 11–19.

Chapter Four

1 Karen Harvey, ed., *History and Material Culture* (Abingdon: Routledge, 2009), p. 7.
2 Ludmilla Jordanova, *The Look of the Past* (Cambridge: Cambridge University Press, 2012), p. 2.
3 See http://cco.vrafoundation.org/index.php/toolkit/
4 David Lowenthal, *The Past is a Foreign Country* (Cambridge: Cambridge University Press, 1985).
5 Glenn Adamson, 'The Case of the Missing Footstool', in Harvey, ed., *History and Material Culture*, p. 192.

6 Christine Johnson, 'Your Granny Had One of Those!', in John Arnold et al, eds., *History and Heritage: Consuming the Past in Contemporary Culture* (Shaftesbury: Donhead Publishing, 1998), p. 73.
7 Sherry Turkle, 'Evocative Objects: Things we Think With', in Hilda Kean and Paul Martin, eds., *The Public History Reader* (Abingdon: Routledge, 2010), p. 162.
8 Iain Robertson, 'Heritage from Below', in Hilda Kean and Paul Martin, eds., *The Public History Reader* (Abingdon: Routledge, 2013), p. 60.
9 Robert Hewison, *The Heritage Industry* (London: Methuen, 1987), p. 98.

Chapter Five

1 Jenny L. Presnell, *The Information Literate Historian* (Oxford: Oxford University Press, 2007), p. 201.